IMAGES
of America

EMERYVILLE

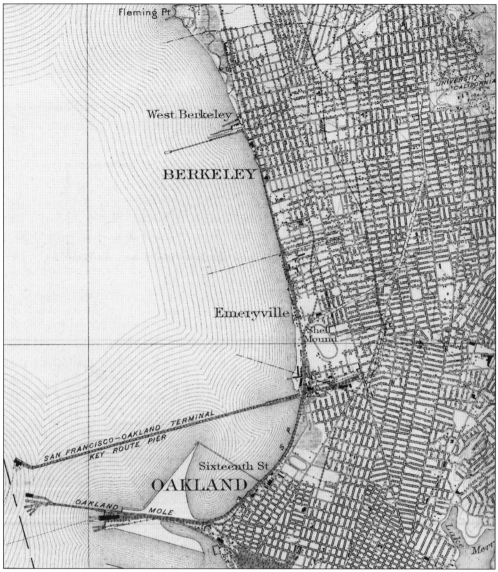

Wedged between Berkeley and Oakland and directly opposite the Golden Gate Bridge, Emeryville occupies a central Bay Area location. This portion of a United States Geological Survey map depicts Emeryville in 1915.

IMAGES
of America
EMERYVILLE

Emeryville Historical Society

Copyright © 2005 by Emeryville Historical Society
ISBN 0-7385-3006-9

Published by Arcadia Publishing
Charleston SC, Chicago IL, Portsmouth NH, San Francisco CA

Printed in Great Britain

Library of Congress Catalog Card Number: 2005926992

For all general information contact Arcadia Publishing at:
Telephone 843-853-2070
Fax 843-853-0044
E-mail sales@arcadiapublishing.com
For customer service and orders:
Toll-Free 1-888-313-2665

Visit us on the internet at http://www.arcadiapublishing.com

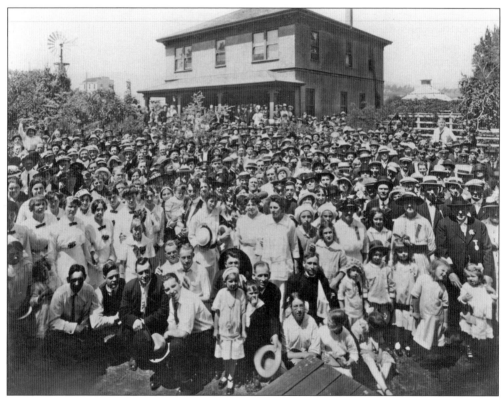

A large gathering poses for the camera at Shell Mound Park in Emeryville around 1914. The Bay Area's "premier amusement resort" offered many attractions, including two dance pavilions, a carousel, a foot racetrack, a bowling alley, a restaurant, a beer garden, a shooting range, and picnic grounds. (Courtesy Oakland Museum of California.)

CONTENTS

Acknowledgments 6

Introduction 7

1. Nature Transformed: Early History 9

2. The Town Without a Church: Incorporation and 19
 Infrastructure

3. Constructing the Crossroads: Transportation 31

4. Industry Builds the City: Emeryville's Business 45

5. Civic Institutions: Gambling and Vice 59

6. Biplanes and Baseball: Sports 71

7. Great Escapes: Recreation and Dining 83

8. The Strips: San Pablo and Park Avenues 95

9. Emeryville in the Second Gold Rush: World War II 109

10. Rebirth: The Contemporary City 119

ACKNOWLEDGMENTS

In 1988, an inquisitive scholar, Theresa McCrea, produced an historic exhibit for an Emeryville brew pub. Stimulated by this interesting subject, she advocated the formation of a society to research Emeryville history. Theresa easily converted a small group of eccentric historians to her cause, and on a stormy night the Emeryville Historical Society was born.

The Emeryville Historical Society developed into a powerful force on the local history scene, creating exhibits, conducting research, collecting photographs and ephemera, and publishing a newsletter, the *Journal of the Emeryville Historical Society*. A group of core members, including Vernon Sappers, Paul Herzoff, Arrol Gellner, Nancy Smith, Donald Hausler, Ray Raineri, Phil Stahlman, and Tony Molatore, became devoted to resurrecting Emeryville's history, which over the decades had been lost, forgotten, and buried. Seth Lunine, a graduate student who joined the Emeryville Historical Society in 2002, worked on chapter introductions and technical aspects of this book.

This pictorial history is the culmination of 17 years of effort. Emeryville Historical Society members have searched libraries and museums throughout the Bay Area for documents, ephemera, and photographs relating to Emeryville history. Most of the photos were discovered in four major institutions: the Bancroft Library, *Oakland Tribune* Library, the Oakland Public Library, and the Oakland Museum. We thank the staffs of these repositories for their expert assistance.

Private parties have been another source of historical images. Vernon Sappers, now deceased, opened his vast collection of railroad photos and contributed to the growing Emeryville Historical Society collection. Ray Raineri, historian and collector, stepped forward to provide us with photos on many subjects. Louis Stein, a Berkeley historian, invited us into his house and enthusiastically shared his photos. Emeryville Historical Society photographers have also been busy over the years shooting old factories and buildings before they succumbed to the bulldozer. Special thanks to Tony Molatore at Clone Art Studio who has performed photographic services for the Emeryville Historical Society for over a decade, and to Yalda Modabber for her wonderful contemporary photographs. We also thank Nora Davis, who has served on the Emeryville City Council, City Manager John Flores, and Acting City Manager Karen Hemphill for their unwavering support of Emeryville Historical Society activities over the last 17 years.

This book is the product of the publication department (Nancy Smith, Donald Hausler, and Seth Lunine) of the Emeryville Historical Society. We have selected over 200 representative photos, many never seen before, that illuminate the rich tapestry of Emeryville history. Enjoy!

INTRODUCTION

Today Emeryville, California, is often described as a phenomenon. This is because the diminutive city, a 1.2-square-mile sliver of shoreline wedged between Berkeley and Oakland, is in the midst of a spectacular redevelopment boom. The dilapidated buildings and contaminated parcels abandoned by heavy industry have been transformed into live-work lofts, shopping malls, corporate campuses, and high-rise hotels. Formerly derided as the "Armpit of Northern California," Emeryville is now heralded as a model of urban renewal. This rebirth, however, is only the latest phase in a succession of major transformations.

A remarkably colorful and distinctive history has unfolded within Emeryville's borders. Before the invasion of European people and pathogens, an Ohlone Indian settlement flourished for millennia within an incredibly lush mosaic of natural habitats. During Spanish and Mexican rule, colossal slaughtering corrals covered creek-fed grasslands as early Emeryville became the heart of Vicente Peralta's cattle operations for the hides-and-tallow trade. A fleeting bucolic period followed the California Gold Rush, but subsequent railroad development and a flurry of real estate speculation fueled urban expansion. The incipient city emerged on Oakland's fringe as a haven for gambling, stockyards, and steel mills. When gambling and associated "recreations" sputtered, Emeryville's niche as an industrial district crystallized. The manufacturing of steel, petroleum, chemicals, and electronics fueled Emeryville's development well into the 1960s. Blight and pollution characterized Emeryville during a protracted decline of heavy industry, but a "business friendly" government armed with increasingly aggressive and innovative redevelopment policies helped engender today's commercial renaissance par excellence. Indeed, the history of Emeryville can be distilled into one word: transformation.

This collection of historical photographs depicts Emeryville in its varied historical guises and also provides insight into the city's unique character and trajectory of development. Some chapters illustrate specific eras, such as the early history of the Ohlone and Californios, the origins and incorporation of Emeryville at the turn of the 19th century, an industrial boom during World War II, and contemporary renewal. Other chapters illuminate enduring factors or themes in Emeryville's development including transportation innovations, industrialization, gambling, sports, and recreation.

These photographs were selected to provide a sense of the vibrant cultures, spectacles, and everyday scenes that have endowed Emeryville with different meanings and identities over time. We hope that these images will reveal the values and intentions of people and enterprises that have conditioned the course of change and will help excavate a history that has been literally bulldozed by "progress."

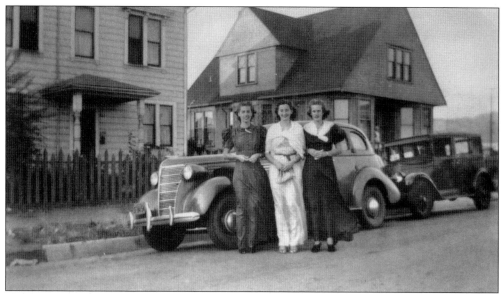

Edwin Warren's three daughters—from left to right, Ruth, Julie, and Mary—pose in front of their house at 1294 Sixty-fifth Street in north Emeryville. They are all dressed up for a special occasion and ready to be whisked away in the new 1938 Chevy. When they were growing up, their father operated a 12-cow dairy in the backyard and delivered milk to families in the neighborhood. (Photograph by Louis Stein; courtesy of Oakland History Room.)

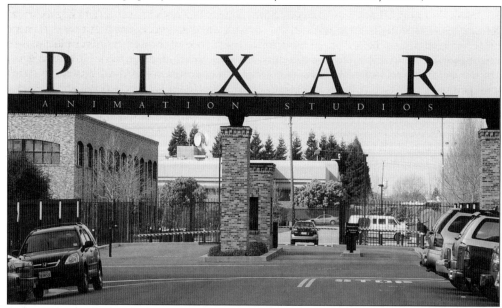

Today Warren's dairy is long gone, and the only farm in Emeryville is Pixar Animation Studios' massive cluster of animation-processing computers known as the "render farm." Pixar, which produces feature-length, animated films including *Toy Story* and *Finding Nemo*, is among Emeryville's most prominent high-tech firms. In order to create an expansive, secure site, Emeryville conveyed ownership of portions of two public streets to Pixar. The sprawling, 13-acre campus on Park Avenue includes brick-faced buildings containing over 150,000 square feet of office space, animation studios, and a massive screening theater. (Courtesy Yalda Modabber.)

One

NATURE TRANSFORMED
EARLY HISTORY

Today Temescal Creek flows placidly through culverts and channels beneath Emeryville's buzz and bustle. It is difficult to imagine that this concrete-lined rivulet is the last vestige of a luxuriant past. Before the Californios' cattle or the Yankees' exploitation of land and labor, Temescal Creek's perennial flow cut a cross-section through the East Bay's natural landscape: from ancient redwoods on the Oakland hills' fog-laden crest to vast oak groves cloaking the foothills, and through grasslands on the alluvial plane comprising the San Francisco Bay's eastern shore. The creek decanted into the bay where willows, marsh, and mudflats converged. But the most salient feature of the landscape was man-made.

Ohlone Indian shell mounds towered above Temescal Creek's mouth. Likely beginning as refuse piles, over centuries the shell mounds grew in size and significance as the site of settlement and ceremony. Emeryville comprised a slight but vital portion of the territory of the Huchiuns— one of about 50 politically autonomous village-communities, or tribelets, of Ohlone Indians. During centuries of insular existence, a seamless interdependence evolved between humans and nature, helping both culture and ecology to flourish. Now poisoned, buried under concrete, or carted off, the Emeryville shell mounds were the accumulation of 2,500 years of human settlement, a testimonial to a landscape of vitality and, as it would turn out, vulnerability.

The mechanisms of Spanish Empire—missions, presidios, and pueblos—enveloped the Bay Area and the colonizers eradicated indigenous culture. Records from Mission Dolores and Mission San Jose document hundreds of Huchiun baptisms by 1794, as well as soaring death rates.

Emeryville became part of Vicente Peralta's Spanish land grant and, by the 1840s, his hides-and-tallow trade burgeoned. But the trajectory of the Californios' socioeconomic development was truncated; the gold rush changed everything. Uninhibited by law or custom, squatters appropriated Peralta's cattle and crops and occupied his land. Peralta, like the Ohlone before him, had become a stranger on his own land.

Real estate speculators acquired the bulk of Vicente Peralta's landholding and began selling tracts in 1856. As deeds churned, farmhouses and fences multiplied. In 1859, Joseph S. Emery purchased a 180-acre tract and built a mansion in the wheat fields. Census reports indicate that early Emeryville's landowners were farmers. But census data belie the intentions of those who invested gold rush profits in East Bay property. Emeryville's "pioneers" are more accurately described as "prospectors." In 1869, the nation's first transcontinental railroad arrived in Oakland, and the prospectors were poised to strike it rich.

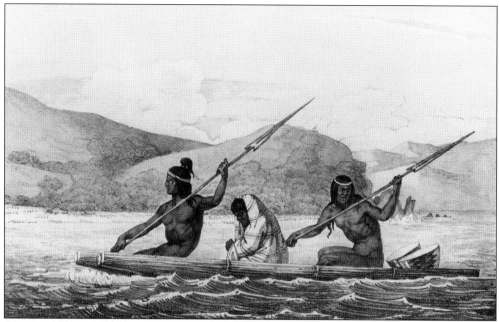

The Ohlone Indians navigated the San Francisco Bay in small, lightweight boats made from tule reeds lashed together in bundles. The boats, 10 to 14 feet in length, were propelled by double-bladed oars. This 1916 lithograph, entitled "Boat of the Port of San Francisco," was created by Louis Choris. (Courtesy California Historical Society.)

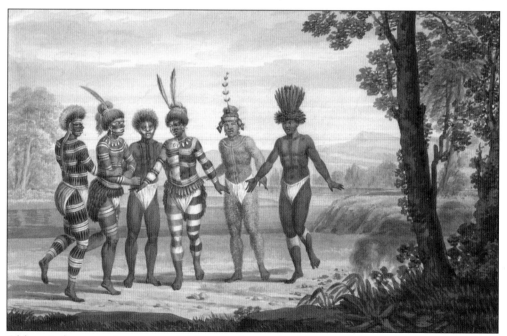

Ohlone Indians wearing ceremonial dress perform a ritual dance at Mission San Jose in southern Alameda County. This scene, titled "Dance of Indians at Mission San Jose," was painted by a German explorer who visited the area early in the 19th century. (Courtesy Bancroft Library, University of California, Berkeley.)

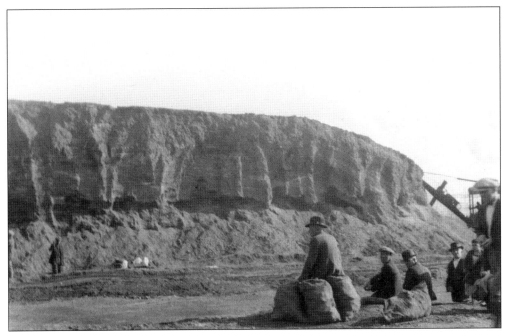

An Emeryville shell mound located near the mouth of Temescal Creek was the site of an Ohlone village. Created over 2,500 years, the mound measured about 40 feet high and 270 feet in diameter. The vast scale of this former landmark is discernible when contrasted with the man standing near its base. (Courtesy Oakland History Room.)

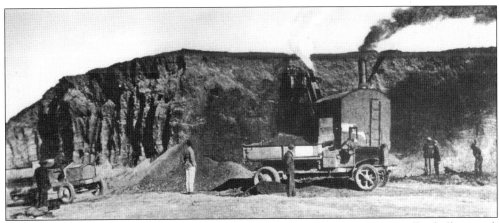

A group of spectators watch a giant steam shovel (right) level an Emeryville shell mound. The shell mound was removed in 1924 to make room for industrial development. Fortunately, anthropologists excavated the site and retrieved numerous bones and artifacts before the shell mound was destroyed. (Courtesy Phoebe Hearst Museum of Anthropology and the Regents of the University of California.)

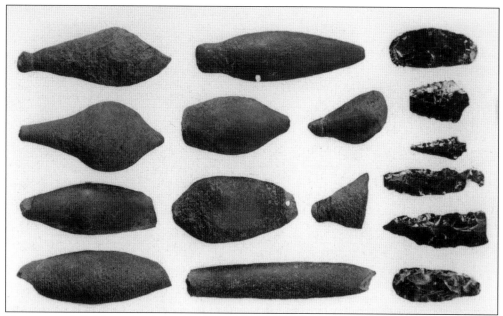

University of California anthropologist W. E. Schenck discovered a large number of artifacts made of stone, bones, and other materials while excavating the Emeryville shell mound. These implements were used for hunting, basketmaking, and other activities. (Courtesy Phoebe Hearst Museum of Anthropology and the Regents of the University of California.)

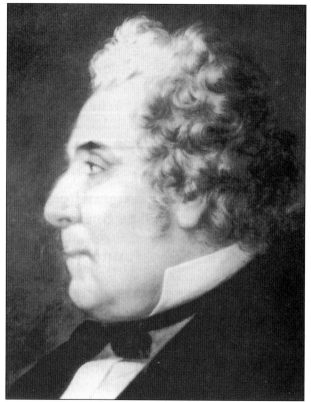

In 1842, Luis Peralta divided the 44,800-acre Rancho San Antonio among his four sons. The youngest, Vicente, pictured here, inherited the land northwest of Lake Merritt, which included the area that later became Emeryville. Over a period of years, Vicente built several adobe buildings near Temescal Creek in North Oakland and raised cattle for hides and tallow. (Oil painting by Ernest Etienne Narjot, 1872.)

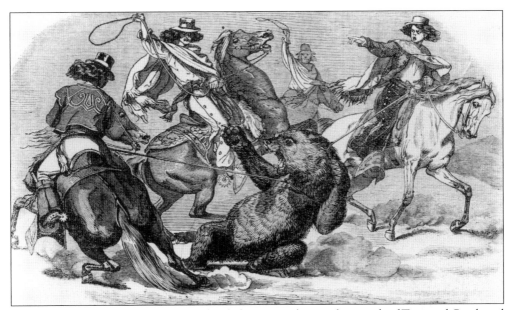

Vicente Peralta raised cattle that were herded into corrals near the mouth of Temescal Creek and slaughtered. Grizzly bears would smell the blood and scavenge scraps of meat. For amusement on moonlit nights, vaqueros chased the bears on horseback, attempting to lasso and capture them. This steel engraving, entitled "The Grizzly and his Captors," was produced by Anthony and Baker, San Francisco. (Courtesy California Historical Society.)

A native of Massachusetts, Frederick Coggeshall settled in San Francisco in 1849. He married Lavinia Rogers in 1852, and then purchased a 45-acre tract of land—perhaps the first American settlement in what later became the community of Emeryville. The Coggeshalls assembled a small house, which had been shipped around Cape Horn, on San Pablo Avenue near today's Forty-fifth Street, farmed the land, and raised pigs and cattle. (Courtesy Emeryville Historical Society.)

13

Born in New Hampshire, Joseph Emery arrived in San Francisco in 1850. He created a successful stonework contracting business and in 1859 purchased a 185-acre tract in the East Bay that was originally part of the Vicente Peralta rancho. A pioneer developer, Emery subdivided his tract into lots in hopes of selling them to land-hungry pioneers. (Courtesy *San Francisco: Its Builders Past and Present*, Vol. II.)

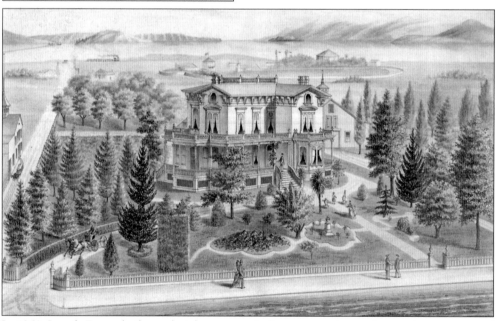

In 1868, Joseph Emery built a palatial two-story Italianate mansion at the northwest corner of Park and San Pablo Avenues in today's Emeryville. The spacious rooms had ceilings 12 feet high from which hung chandeliers of crystal and brass. Emery died in 1909, and the mansion was razed in 1946. (Courtesy Thompson & West *Historical Atlas of Alameda County*, 1878.)

14

Born in Connecticut, Edward Wiard immigrated to San Francisco in 1850. After working in the mines, he returned to the Bay Area and in 1859 purchased 115 acres of land located north of the Emery Tract. Wiard built the Oakland Trotting Park and Shell Mound Park on his property, transforming the community of Emeryville into the East Bay's entertainment capital. (Courtesy Wood's *History of Alameda County*, 1883.)

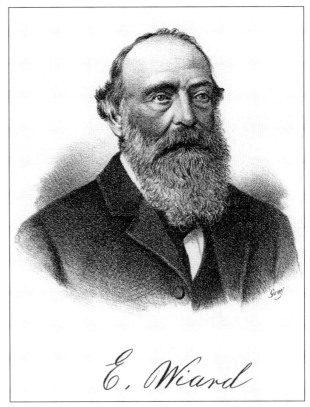

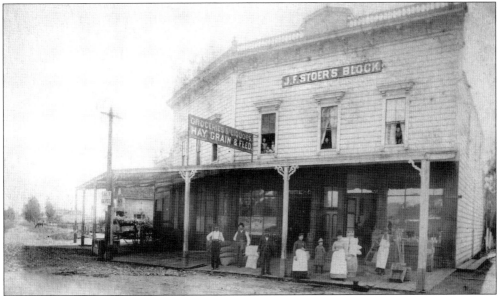

Originally from Minnesota, John Stoer and his son Fred arrived in San Francisco in 1877. In the 1880s, they bought property in the vicinity of Adeline Street and San Pablo Avenue and opened a general store. The sign above the windows reads "J. F. Stoer's Block." Jutting out from building, another reads "Groceries & Liquor. Hay, Grain & Feed." Fred Stoer was elected to Emeryville's first city council. (Courtesy Emma Callahan.)

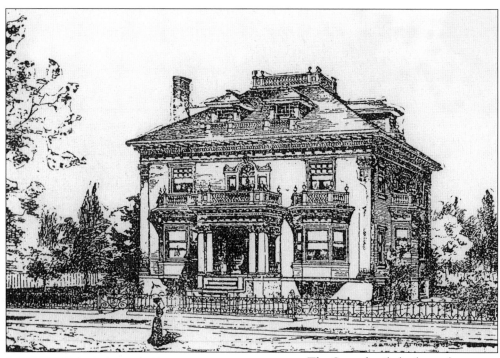

The Stoer family built an elegant three-story mansion near Thirty-eighth and Adeline Streets in 1901, which was designed by the Oakland architectural firm Arnold and Soderberg. The front porch was framed by Greek columns and the interior finished in exotic woods. (Courtesy *Oakland Inquirer*, September 5, 1901, page 3.)

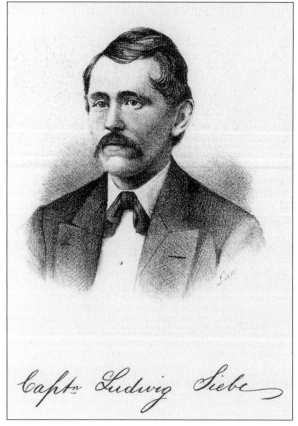

A native of Germany, Ludwig Siebe immigrated to the United States in the 1860s and served in the New York Infantry during the Civil War. After moving west to San Francisco in 1867, he joined a National Guard unit, achieving the rank of captain. In 1879, Siebe leased Shell Mound Park and expanded it into the Bay Area's premier "pleasure park." (Courtesy Wood's *History of Alameda County*, 1883.)

This pioneer dwelling, dating back to the 1870s, was located east of San Pablo Avenue near Forty-third Street. Two distinct sections were added to the original wood-framed domicile. The house was razed in 1990. (Courtesy Emeryville Historical Society.)

A child stands on an old wooden footbridge that crossed Temescal Creek near present-day San Pablo Avenue and Fifty-third Street in the 1870s. The creek at this location served as the boundary between Emeryville and Oakland when Emeryville incorporated in 1896. (Courtesy Oakland History Room.)

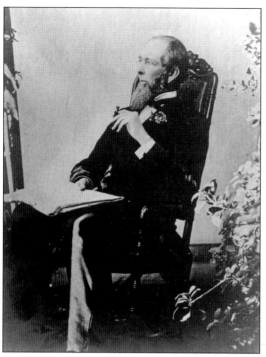

In the 1870s, John L. N. Shepard bought a tract of land in the emerging Emeryville community that extended from San Pablo Avenue west to the Oakland Trotting Park. Shepard and his business partner, Egbert Judson, were the proprietors of the San Francisco Chemical Works and Sulphur Powdering Mill in West Berkeley. (Courtesy Oakland Museum of California.)

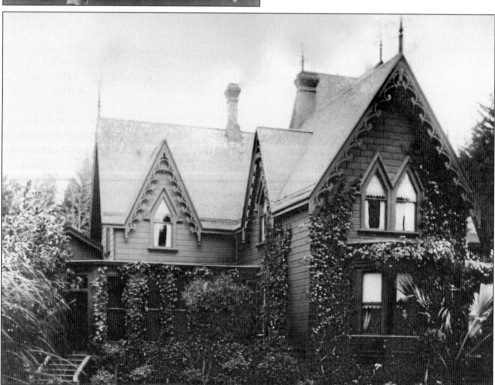

Around 1875, John Shepard built a stately residence on the west side of San Pablo Avenue near Temescal Creek. This was one of several mansions that graced San Pablo Avenue in the late 19th century, all of which have disappeared. (Courtesy Oakland Museum of California.)

Two

THE TOWN WITHOUT
A CHURCH
INCORPORATION AND INFRASTRUCTURE

In 1869, the United States' first transcontinental railroad, the Central Pacific, reached Oakland. The ensuing urban-industrial boom transformed this modest satellite of San Francisco into a budding rival. Oakland expanded in every direction as the population almost quadrupled over the following decade. During this flurry of metropolitan expansion, Joseph Emery financed the East Bay's second horse-car line to connect downtown Oakland to a terminus on Emery's tract, where freshly platted residential lots would seemingly ripen for sale. Yet as individual landowners and assorted "landsharks" began subdividing tracts, visions of a bedroom community were challenged. When the horse cars arrived in 1871, another early landowner promptly finished constructing a mile-long horse racing track known as the Oakland Trotting Park. Saloons, brothels, and card clubs materialized on nearby Park Avenue. Then came Emeryville's first steam train, and it delivered more than revelers.

In 1878, the Northern Railway placed early Emeryville on the East Bay's incipient industrial axis, which ran the shoreline from Oakland to California's wheat-shipping hub at Port Costa on the Carquinez Strait. Transportation connections, a glut of cheap land, and a location just north of Oakland's jurisdiction primed Emeryville for industry. Abattoirs (slaughterhouses) trailed the railroad to Emeryville's northern shoreline, an area known as Butchertown. Shoreline property also attracted heavy manufacturing. Many of Emeryville's early residents followed the factories and found housing in boarding houses and residential hotels.

The city, however, did not develop in isolation. Residents of adjacent neighborhoods targeted early Emeryville's noxious industries and "morally reprehensible" activities for reform. United by the economic imperative of protecting assets and investments, early Emeryville landowners, investors, and industrialists drew and redrew the boundaries of the city to circumvent the bulk of adjacent residential neighborhoods and to exclude every church. On December 2, 1896, Emeryville was incorporated as an autonomous municipality by a vote of 150 to 27.

Emeryville became the antithesis of the picturesque suburban community. Be it stockyards, gambling, or steel mills, the city cultivated activities proscribed or shunned elsewhere. Nevertheless, a small community did prosper. A dozen African Americans joined residents of French, Portuguese, and British lineage. Emeryville's first schools were in place by 1885, and its fire department boasted the latest equipment. In 1903, the city council moved its meetings from the Commercial Union Hotel to a monumental city hall on Park Avenue. Emeryville had come of age, though its residents had to join churches in Oakland.

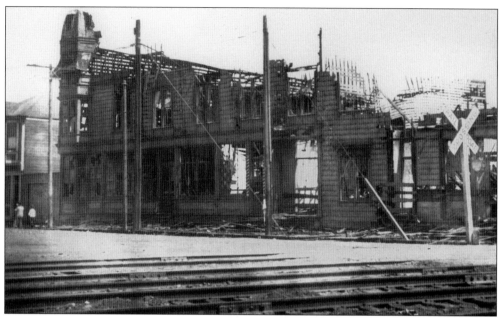

The Commercial Union Hotel opened in 1888 at the foot of Park Avenue next to the railroad tracks. The two-story, wood-frame structure contained 68 sleeping rooms, four stores, a card room, saloon, and dining room. From 1896 to 1903, the Emeryville Board of Trustees conducted business in two rooms of the hotel. The building was destroyed by fire on May 6, 1910. (Courtesy California Photo Views.)

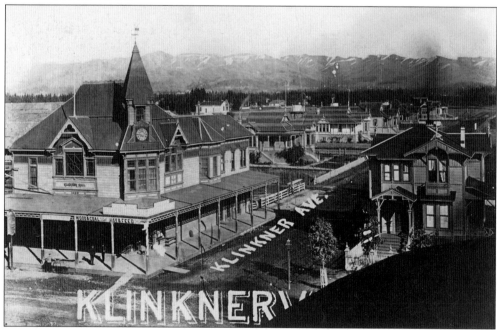

Klinkner Hall, built by Charles Klinkner in 1886, stood at the northeast corner of San Pablo Avenue and Fifty-ninth Street in the community of Klinknerville. This three-story Gothic building, with shops on the first floor and meeting rooms and apartments on the upper floors, also served the adjacent Emeryville neighborhood. (Courtesy California Photo Views.)

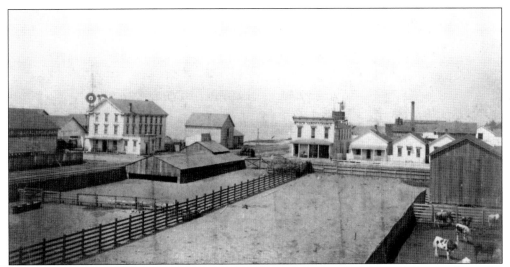

The Butchertown District, later known as the Stock Yards, emerged in north Emeryville in the 1870s. This c. 1890 panoramic view shows the Golden Gate Hotel (left) and the Stock Yard Exchange Hotel (center) located at the foot of Dalton Avenue (now Sixty-fifth Street). Corrals and cattle are in the foreground. (Courtesy California Photo Views.)

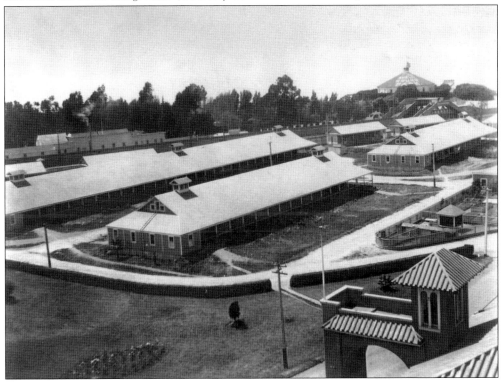

The Oakland Trotting Park, built by Edward Wiard, opened in 1871. Thomas Williams Jr. leased the track in 1894, and in 1896 he rebuilt the grandstand and upgraded the facilities. This 1908 photograph shows the stables and buildings that comprised the racetrack complex. The Shell Mound Park dance pavilion looms in the background. (Courtesy Oakland Museum of California.)

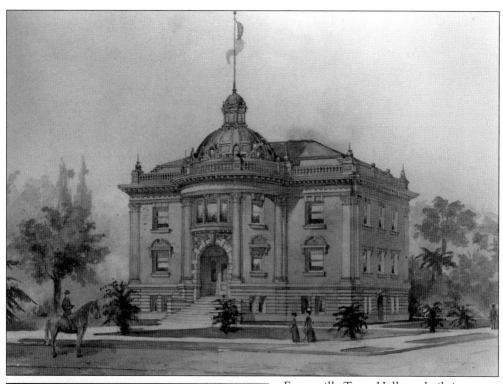

Emeryville Town Hall was built in 1903 at the southeast corner of Park Avenue and Hollis Street. The two-story neoclassical brick edifice featured a large copper dome. The building served as the city hall for 68 years, closing in 1971. The old town hall, having been restored and retrofitted, reopened in 2000. (Courtesy Emeryville Historical Society.)

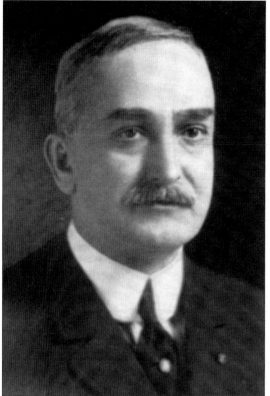

When Emeryville incorporated in 1896, Wallace Hunt Christie was elected by the board of trustees to serve as mayor and held this position until his retirement in 1936. During his reign, Christie transformed Emeryville into a center of industry and, according to his detractors, a center of vice. (Courtesy Davis's *Commercial Encyclopedia of the Pacific Southwest.*)

Pictured in 1909, this "flatiron" building, located at the gore (a triangular piece of land) formed by San Pablo Avenue and Adeline Street, opened as Syndicate Bank in 1903. Syndicate Bank became First National Bank, then First Savings Bank, and finally Wells Fargo Bank in 1962. In the late 1980s, the building operated as the Sands Club Card Room. (Courtesy Oakland Museum of California.)

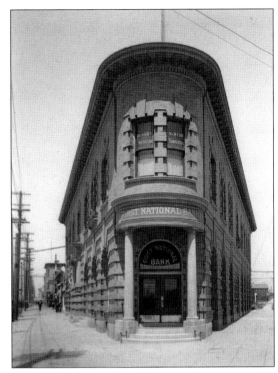

Emeryville's first firehouse, located on San Pablo Avenue near Forty-fifth Street, was built in 1910 at a cost of $9,133. The two-story Mission-style building featured two arched garage doorways, a tile roof, and a tower for drying hoses. The first floor functioned as a garage for fire trucks and also housed an alarm center. The second floor contained a dormitory, kitchen, and sitting room. (Courtesy Emeryville Fire Department.)

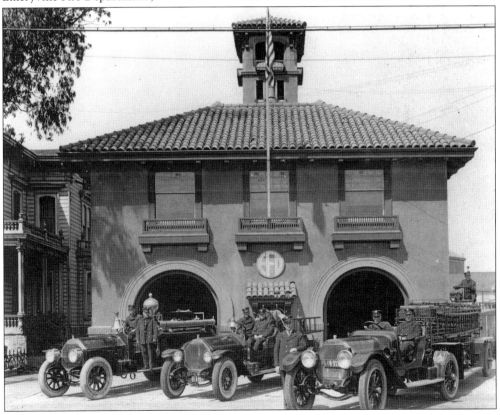

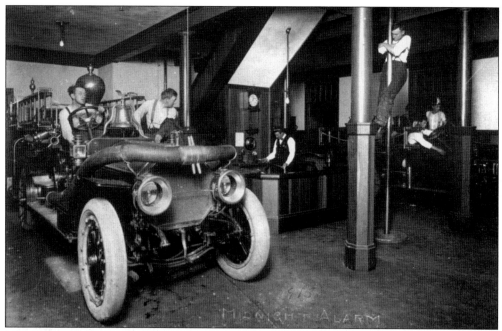

This rare 1915 photograph shows Emeryville firemen springing into action after the report of a fire. The engineers are starting up the Webb pumper while Chief Culver (center) reads the tickertape that locates the fire. A sleepy fireman descends the fire pole. (Courtesy Henry Lyman.)

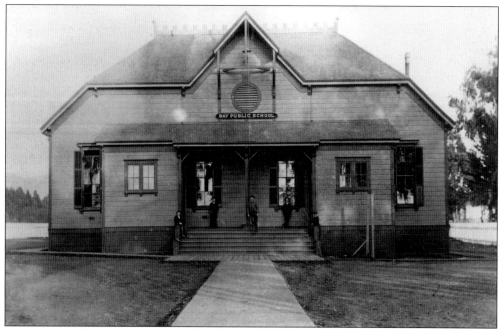

Bay Public School, located at San Pablo Avenue and Sixty-second Street, served the northern Emeryville and the Golden Gate community during the late 19th century. This school, pictured here in 1884, was later replaced by a two-story structure. The site is now occupied by Golden Gate Elementary School. (Courtesy Oakland Museum of California.)

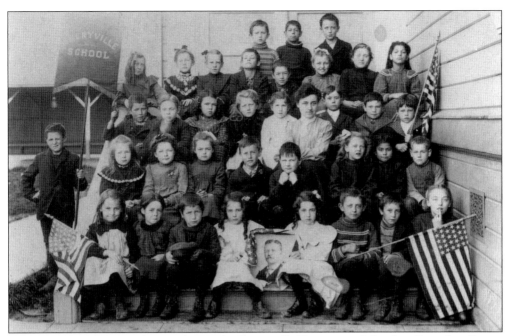

This 1905 class photograph was taken at the Emeryville Elementary School on Forty-first Street. Note the identical twins holding a photograph of Pres. Theodore Roosevelt. The four-room schoolhouse opened in 1886 as the Emery Elementary School, but the name was later changed to Emeryville School. (Courtesy Ray Raineri.)

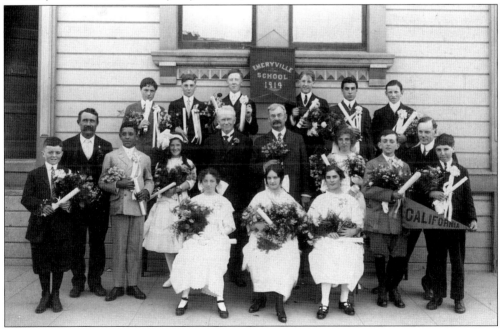

The 1914 graduates of Emeryville Public School, grasping bouquets and diplomas, pose for a photograph. The school was located on Forty-first Street between San Pablo Avenue and Adeline Street, with D. B. Lacy serving as principal in 1914. The school was later renamed in honor of his successor, Anna Yates. (Courtesy Ray Raineri/Ed Clausen.)

The North Emeryville School was located at the northwest corner of Sixty-first and Doyle Streets. This grammar school, built in 1910, served the north end of town for almost 20 years. The wood-frame building was replaced in 1929 by a new brick school located across the street. It was renamed John A. Sutter and later Ralph S. Hawley Elementary School. (Courtesy Oakland History Room.)

In 1920, a new two-story school opened at the corner of Forty-seventh Street and San Pablo Avenue to accommodate the upper elementary grades. The building was later converted into a high school, Emery High, and its first class graduated in 1928. This structure has been replaced by a modern one-story school. (Courtesy Emery High School.)

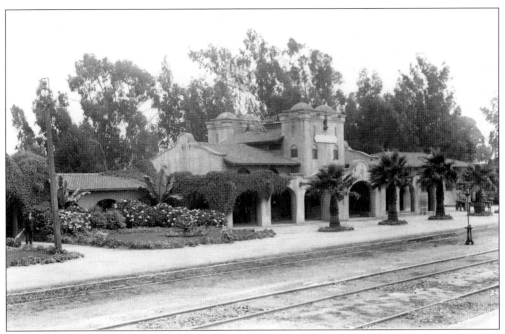

Emeryville became a terminus for the Santa Fe Railroad's transcontinental line in 1904. The same year, a Mission-style passenger depot was built at the corner of Fortieth Street and San Pablo Avenue. Santa Fe discontinued passenger service to Emeryville in 1958, and the depot, pictured here in 1916, was demolished in 1961. (Courtesy California Photo Views.)

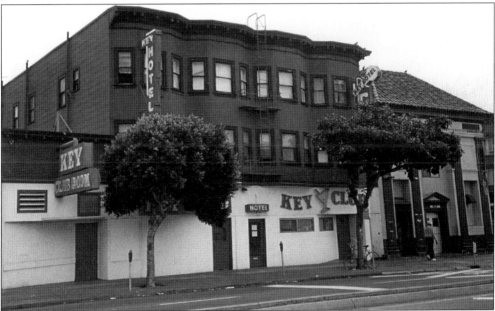

In 1906, the Santa Fe Hotel was built on San Pablo Avenue across the street from the Santa Fe train station in order to accommodate passengers. The three-story building was renamed the Key Hotel in 1938 and housed a popular card room and cocktail lounge until the late 1980s. It stood vacant for a decade before finally being razed in the late 1990s. (Courtesy Emeryville Historical Society.)

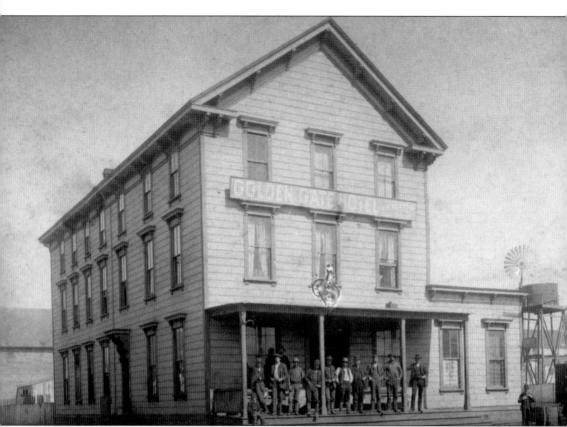

Although surrounded by slaughterhouses and corrals, the Golden Gate Hotel was the most prestigious address for laborers in Emeryville's stockyards district. Pictured here *c.* 1875, it was located on the Northern Railway tracks at the corner of Bay Street and Dalton Avenue (now Sixty-fifth Street). The hotel's tenants are gathered on a porch flanking the southern side of the building. They represent a small portion of the fraternity of rough-hewn apprentice butchers, yard hands, and carpenters that lived in Butchertown. Casual visitors found the pervasive stench of manure and burning bones unbearable. In 1888, an *Oakland Tribune* reporter described the sounds: "What with the low moaning of doomed cattle, the shrieking of swine, the plaintive bleating of sheep, the swish of the knife, the thud of the axe, and the gurgle of escaping blood, the yards are steeped in a potpourri of sound fit for melodramatic action." The Golden Gate Hotel's saloon, billiard room, and dining hall helped its boarders develop a tolerance to the malodorous milieu. The single-story room on the right side on the building served as a train station. (Courtesy Oakland History Room.)

GOLDEN GATE HOTEL,

WM. STORMS, Proprietor,

Northwest Cor. Dalton Ave. and Bay St.,

BOARD AND LODGING ON REASONABLE TERMS.

The Golden Gate Hotel, located in Butchertown, offered board and lodging "at the most reasonable rates." In the late 19th century, Emeryville hotels were often built next to industrial sites to serve the workforce. These hotels were self-contained, providing tenants with meals as well as recreation in the form of poolrooms and saloons. (Courtesy Bishop's *Oakland Directory*, 1878–1879.)

Built in 1929 and pictured here in 1946, the Ritz Hotel was a three-story brick building located at San Pablo Avenue and Yerba Buena. The Avalon Cardroom, Tobenkin Pharmacy, and the La Rue Restaurant occupied the first floor in the 1950s. The building was damaged by fire in 1995 and razed in 1998. (Courtesy Ray Raineri.)

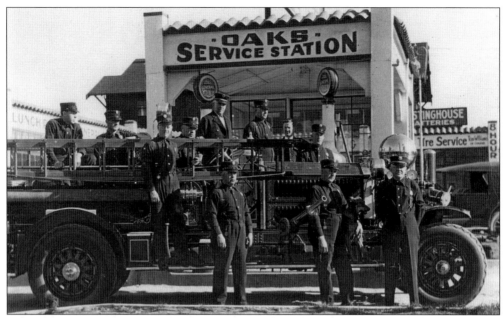

In this 1930s photograph, Emeryville firefighters pose beside their favorite vehicle, the Aherns-Fox Pumper. The stalwart men in front of the fire engine, from left to right, include (first row) Luchetti, Rose, and Rodoni; (second row) Doyle, Weber, Schleason (driver), Wiley, and Captain McGuire. The Oaks Service Station, operated by N. Herlitz & Son, was located across the street from the fire station on San Pablo Avenue. (Courtesy Henry Lyman.)

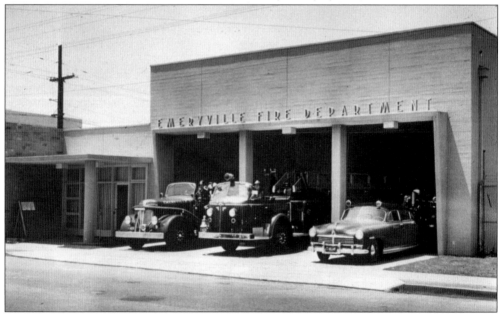

Fire Station No. 2, a modern one-story fire station designed by Mayor Lacoste, was built in 1951 at Sixty-third and Hollis Streets in north Emeryville. Behind the firehouse, a large underground shelter equipped with radios and telephones eased fears regarding a nuclear war. In the event of an atomic bomb attack, firemen could retreat into the shelter and dispatch equipment throughout the city. (Courtesy Henry Lyman.)

Three

CONSTRUCTING THE CROSSROADS
TRANSPORTATION

By the turn of the century, Emeryville had emerged as a transportation hub serving commuters, revelers, and its increasingly large workforce. The city was a bona fide destination. This was not simply the outcome of a "superior location." Emeryville's ethos of unbridled development fostered incessant transportation experimentation. In fact, the history of transportation innovation involving Emeryville serves as a microcosm of the evolution of public transit in the San Francisco Bay Area, if not the entire state of California.

"Railroad fever" reached epidemic proportions after the first transcendental line arrived in Oakland. Joseph Emery bankrolled the San Pablo Avenue Horse Car Railroad to provide early Emeryville with intercity connections. Then the Northern Railway, a thinly-veiled subsidiary of the Southern Pacific, created regional links that sparked industrialization in the late 1870s. Steam railroad development continued in the early 1880s when Emery laid tracks on Yerba Buena Avenue (now covered by the East Baybridge Mall) for his California & Nevada Railroad. Grandiose plans to connect Emeryville to Calendria, Nevada, however, were crushed as the Northern Railway undercut freight costs. The Atchison, Topeka & Santa Fe Railroad eventually acquired the C&N's right-of-way and extended the western end of the nation's second transcontinental railroad from Richmond, California, to a terminus in Emeryville in 1904.

Intercity public transit development proceeded apace with the steam trains. Silver king James Fair purchased the San Pablo Avenue Horse Car Railroad and its Park Avenue branch and converted them to cable car routes. In 1895, Francis Marion "Borax" Smith acquired the cable car lines as part of his design for a transportation and real estate empire. In 1903, Smith's Key System (initially known as the San Francisco, Oakland & San Jose Railway) began service, and trolley lines throughout the East Bay converged on the Yerba Buena corridor on the way to ferry connections on the Key Route pier. Fierce competition between the Southern Pacific's "big red trolleys" and the Key Route system created one of America's grand trolley networks.

The reliance on automobiles and trucks that followed World War I was amplified with the completion of the San Francisco-Oakland Bay Bridge in 1936. Two of the bridge's eastern approaches traversed Emeryville. The highway and bridge projects improved Emeryville's already prime location, perpetuating the city's role as a regional transportation hub.

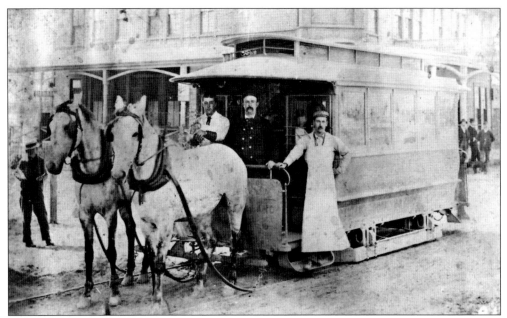

Joseph Emery's San Pablo Avenue Horse Car Line, pictured *c.* 1882, connected Oakland with Emeryville. The line, which began service in 1873, started at Seventh Street in downtown Oakland and ran up Broadway to Fourteenth Street, where it switched off to San Pablo Avenue and continued north for two miles to Park Avenue in Emeryville. (Courtesy Oakland History Room.)

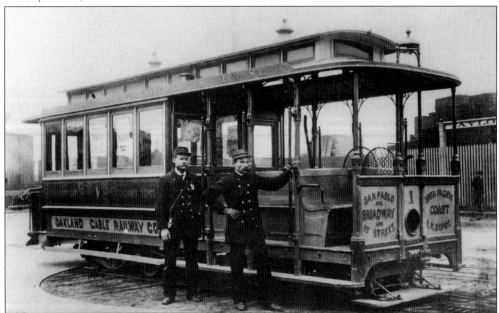

Sen. James Fair, who had made a fortune from the Comstock Lode, bought the San Pablo Avenue horse car line in 1886. He converted it to a cable line the same year and renamed it the Oakland Cable Railroad. The car was hauled by a steel cable that traveled on rollers beneath the street, driven by a stationary steam engine. This image was taken *c.* 1890. (Courtesy Oakland History Room.)

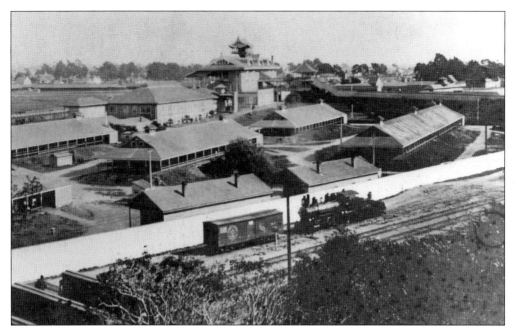

The Northern Railway was the first steam railroad to serve Emeryville. Built in 1876–1877, the railroad connected Oakland with Martinez and Port Costa. This c. 1906 photograph depicts a Northern Railway locomotive, tender, and boxcar near Shell Mound Park. The racetrack's stables and grandstand appear in the distance. (Courtesy California Photo Views.)

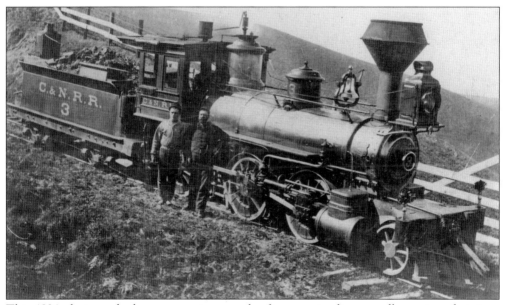

This 1894 photograph shows an engineer and a fireman standing proudly next to their iron steed—a California & Nevada steam engine. Built in the 1880s by Joseph Emery, Capt. John "Denver" Smith, and other investors, the C&N Railroad was a narrow-gauge line that ran from the foot of Yerba Buena Avenue in Emeryville to Orinda, via Berkeley and Richmond. The line failed to prosper and Santa Fe eventually acquired the right of way. (Courtesy Oakland History Room.)

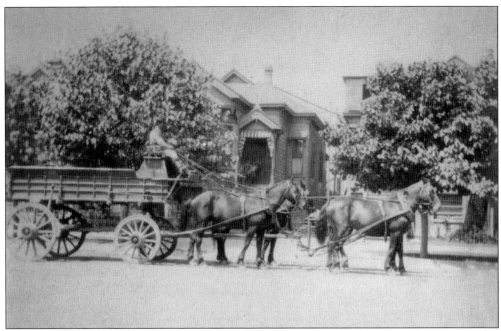

Early in the century, driver Harry Schwatka delivered meat from Butchertown in a wagon drawn by a team of four horses. In this c. 1910 view, Schwatka is headed north on San Pablo Avenue hauling a load of beef. Motorized trucks began to replace wagons in the 1910s to 1920s. (Photograph by Louis Stein; courtesy Oakland History Room.)

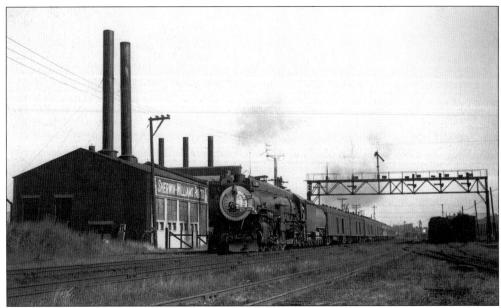

Southern Pacific passenger train No. 25, made up of a large steam locomotive, mail baggage cars, and passenger units, rumbles past the Sherwin-Williams paint factory in Emeryville. This train, known as The Owl, provided overnight service between the Bay Area and Los Angeles via the San Joaquin Valley. A signal bridge stands over the tracks. (Courtesy John Harder.)

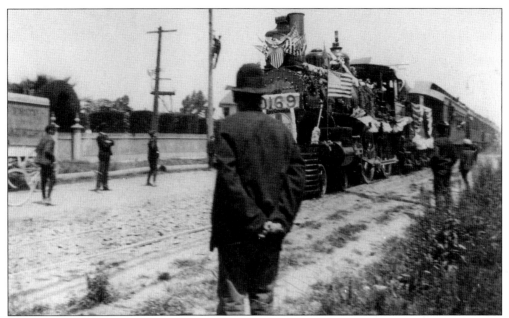

In 1902, the Santa Fe acquired the California & Nevada right of way from Emeryville to Richmond and converted the tracks to standard gauge. With this connection, Emeryville became a terminus for the Santa Fe's transcontinental railroad. The first Santa Fe passenger train, decorated in bunting, came chugging down Adeline Street on May 16, 1904. (Courtesy *Oakland Tribune.*)

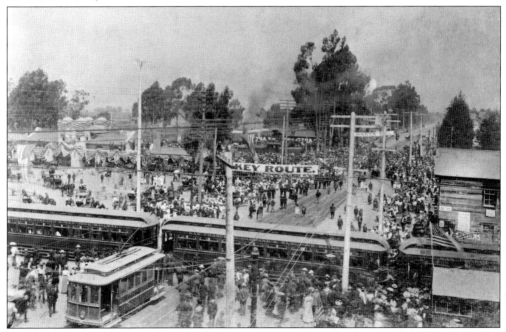

There was a big celebration when the first Santa Fe train arrived in Emeryville on May 16, 1904. The Santa Fe Depot (center left) is draped in flags and bunting for the occasion. A San Pablo Avenue streetcar (bottom left) waits while the San Francisco, Oakland & San Jose Railroad (later Key System) crosses San Pablo Avenue. (Courtesy Oakland History Room.)

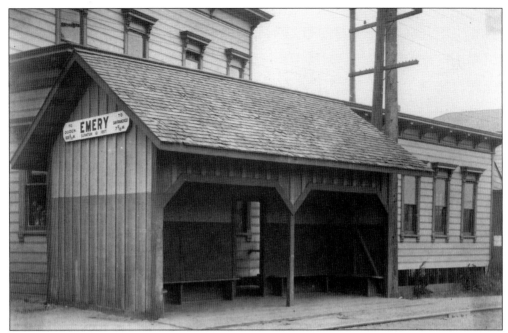

Southern Pacific operated three main passenger stations in Emeryville. Emery Station, located at the foot of Park Avenue and pictured here *c.* 1910, was a small wooden structure open on the side facing the railroad tracks. The Park Avenue streetcar shuttled passengers from the Emery Station to San Pablo Avenue. (Courtesy California Photo Views.)

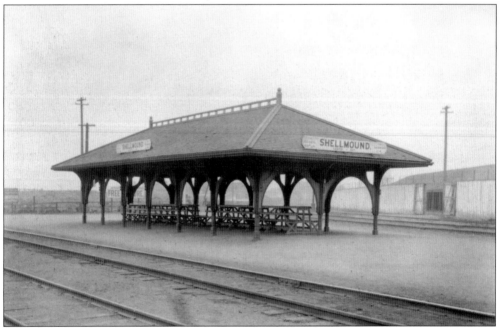

Located north of Emery Station at the time of this 1905 photograph, Shellmound Station served Southern Pacific passengers visiting Shell Mound Park. The park closed in 1924 and the station eventually closed as well, but a "Shellmound" sign next to the main line survived into the present day marking the site of the old station. (Courtesy California Photo Views.)

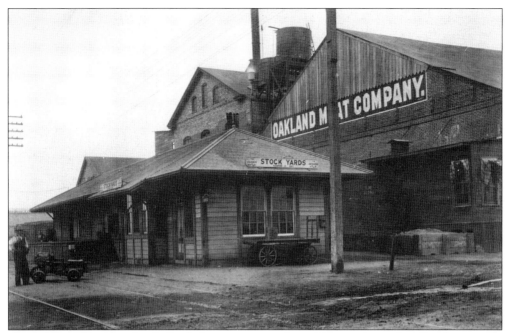

The Southern Pacific's Stock Yards Station, pictured in 1905, was located in Butchertown at the foot of Sixty-fifth Street, adjacent to the Oakland Meat Company. The Stock Yards Station served the Butchertown neighborhood for several decades before the Southern Pacific's Red Trains ceased operation in 1941. (Courtesy California Photo Views.)

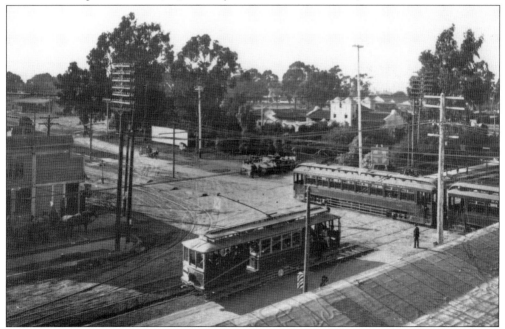

The San Pablo Avenue cable car line was converted to electric powered street cars in 1899. In this c. 1904 scene, a streetcar waits on San Pablo Avenue for the San Francisco, Oakland, and San Jose train to cross San Pablo Avenue. This route later became part of the Key System. (Courtesy Oakland History Room.)

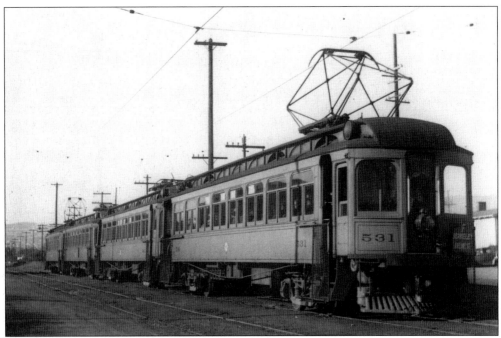

This 1935 photograph shows the Key System 500 class cars, the predecessor to the more modern bridge railway units. The cars are lined up on Linden Street near Forty-third in Emeryville on the Berkeley F line. (Courtesy John Harder.)

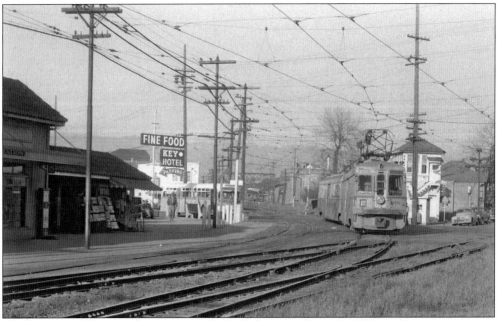

Berkeley-bound Bridge Unit 178 rolls out of Key System's Emeryville Station in 1955. The F and E lines shared the right of way on Linden Street to Fifty-fifth Street, where the E line continued up to Claremont Avenue and its terminus at the Claremont Hotel. The C line's (Piedmont) tracks on Yerba Buena Avenue are on the right of Key System Tower No. 3, which is just to the right of the train. (Courtesy John Harder.)

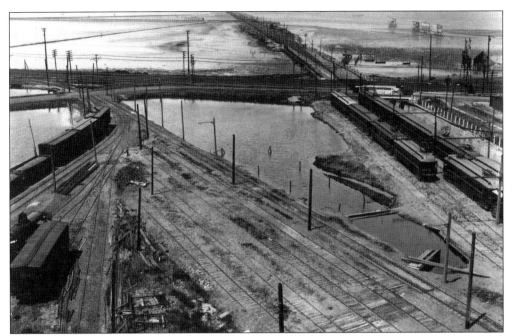

The Key System Mole is seen in this 1914 photograph, taken from one of two Key System powerhouse smokestacks. Key System trains entered a subway (on the right) that went under the Southern Pacific tracks, and then continued on a pier out to the mole where passengers boarded a Key ferry to San Francisco. (Courtesy John Harder.)

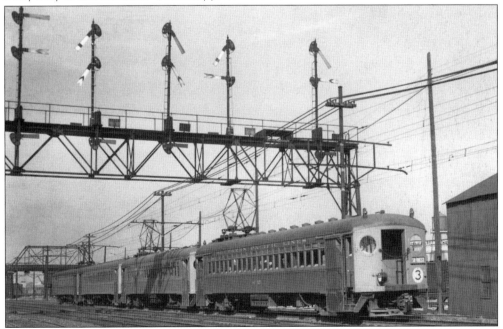

Four units of Southern Pacific's interurban electric railway, also known as the Red Train because of its brightly painted cars, move under semaphore signals near the foot of Park Avenue in Emeryville. The No. 3 line was the Berkeley–Shattuck Avenue run, and this c. 1940 photograph captures a midday trip from San Francisco. (Courtesy California Photo Views.)

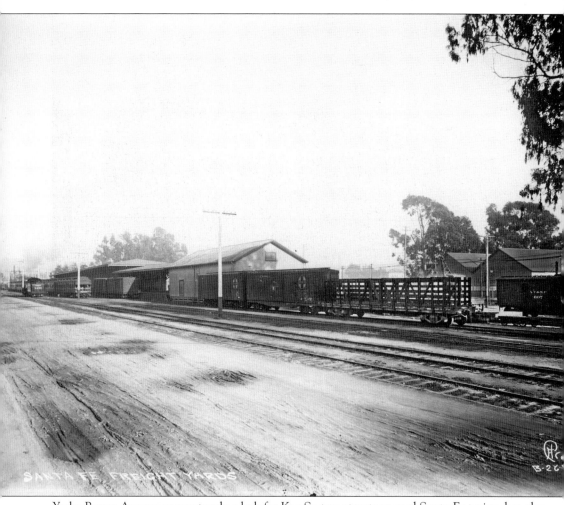

SANTA FE FREIGHT YARDS

Yerba Buena Avenue was not only a hub for Key System streetcars and Santa Fe trains, but also the center for Emeryville's transportation-related industries. This c. 1920 photograph shows a line of freight cars at the Santa Fe Yards, located near the southwest corner of Yerba Buena and San Pablo Avenues. In addition to the Santa Fe Yard, hay and grain storage facilities, the American Fuel Company's coal yards, and freight-handling companies lined the corridor west of San Pablo Avenue. The Key System Shops are shown on the right of the photograph. Constructed in 1905, the shops consisted of a dozen buildings on a site straddling the Emeryville-Oakland border. Trolleys were built, painted, and repaired in the shop's facilities, which included an engine room, a kiln, a foundry, and machine, paint, and carpenter shops. By the late 1950s, the Key Route trolleys and Santa Fe trains ceased operation on Yerba Buena, and the Key System Shops were dismantled. Then trucking depots dominated Yerba Buena Avenue. In the early 1990s, Caltellus Development Corporation (then the real estate arm of the Santa Fe Railroad) developed the East Baybridge Mall. Today Yerba Buena Avenue is buried under the mall's expansive parking lot. (Courtesy California Photo Views.)

40

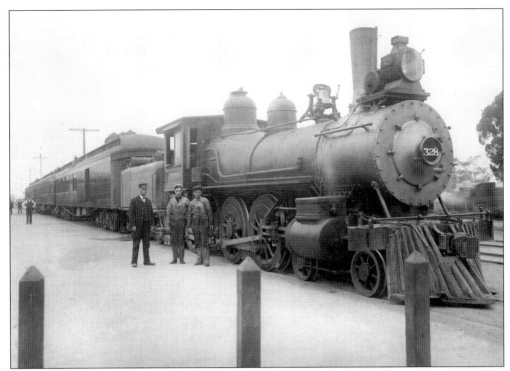

Santa Fe steam locomotive No. 328, photographed around 1910, is ready to steam out of the Santa Fe Depot at Fortieth Street and San Pablo Avenue. The conductor, engineer, and fireman proudly pose for the cameraman. The train consists of a combine car (baggage and passengers) and two coaches. (Courtesy California Photo Views.)

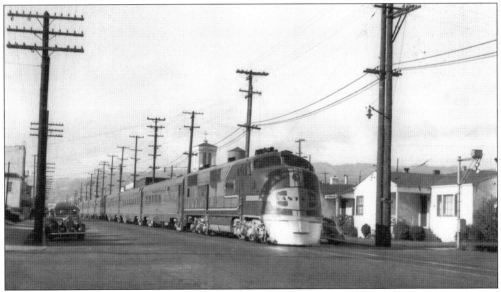

In this 1945 photograph, an inbound Santa Fe passenger train, the "Golden Gate," moves south past the intersection of Adeline and Forty-third Streets on its way to the Santa Fe Depot, only a few blocks away. Note the wigwag-style signal to protect the intersection. The monumental Remar Bakery tower looms in the background. (Courtesy John Harder.)

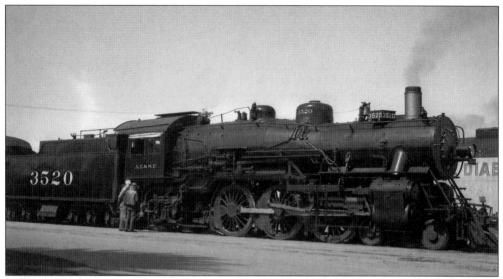

An engineer stands next to his iron horse, steam engine No. 3520, a 4-6-4 Santa Fe locomotive, that is parked in front of the Santa Fe Depot near Fortieth Street, west of San Pablo Avenue in 1945. Steam locomotives were used to haul freight trains until diesel units replaced them in the 1950s. (Courtesy John Harder.)

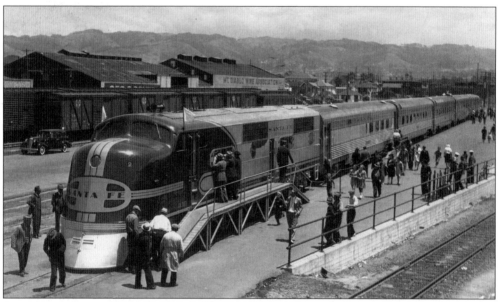

Santa Fe's new "Golden Gate" Streamliner was placed on exhibit in Emeryville's Santa Fe station in 1938. This section of the Santa Fe track is now Fortieth Street. A portion of the Mount Diablo Wine Association structure remains today and is known as the Black and White Liquor Store. (Photograph by Ralph DeMoro; courtesy John Harder Collection.)

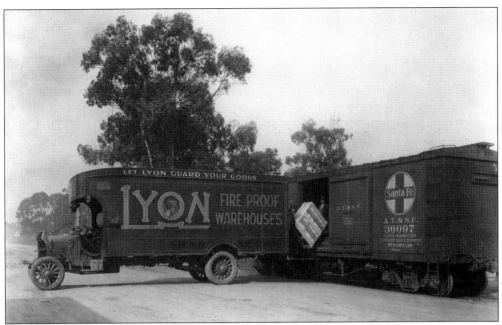

In this 1916 view, workers are unloading cargo from a Lyon moving van onto a Santa Fe freight car at the Santa Fe freight siding in Emeryville. Note the American flag attached to the front fender. (Courtesy Oakland Museum of California.)

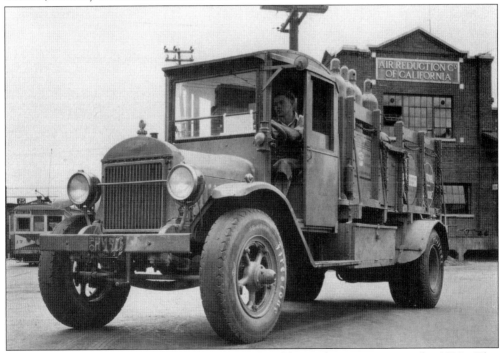

Trucks came into competition with the railroad and horse-drawn wagons in the 1920s. This heavy-duty, dual-wheeled Mack delivery truck, photographed in 1931, is carrying a load of oxygen tanks from the Air Reduction Plant at the foot of Park Avenue. The Park Avenue Key System streetcar is seen at bottom left. (Courtesy Vernon Sappers.)

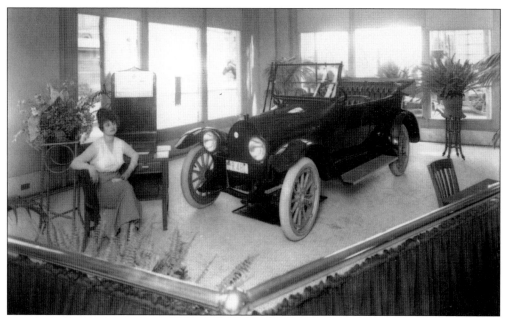

Cozzens-Ball Incorporated Motor Company opened in 1925 at the corner of San Pablo Avenue and Thirty-eighth Street. This large facility, which had 45 employees, consisted of an automobile showroom and a garage. It opened as the Star Car Agency, pictured above in 1925, but later sold Hudson, Ford, Lincoln, and Crosley automobiles. The building still exists in its original condition. (Courtesy Oakland Museum of California.)

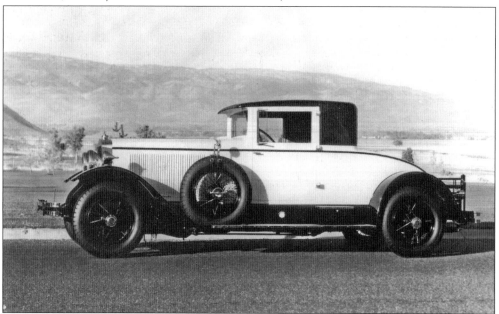

In 1920, Abner Doble created the Doble Steam Motors Corporation in San Francisco. In 1923, he moved the business to Emeryville and built a new factory on Harlan Street, one block south of Park Avenue. The factory manufactured the magnificent Series E Doble, a steam car with a top speed of 85 miles per hour. The plant built only 44 Dobles before it stopped production in 1931. (Courtesy Emeryville Historical Society.)

Four

INDUSTRY BUILDS
THE CITY
EMERYVILLE'S BUSINESS

In the early 1880s, industry rumbled onto Emeryville's shoreline. Countless cattle, sheep, and hogs met their fate in Emeryville's Butchertown, a collection of malodorous slaughterhouses and by-products factories perched on waterfront piers. At Judson Iron Works, the workforce operated four blast furnaces and toiled in workshops to produce agricultural machinery and an array of hardware. The Paraffine Paint Company's processing of oil derivatives into waterproof paint quickly attracted small-scale petroleum refineries and distributors. New canneries began processing Northern California's produce bonanzas and a can factory soon followed. The rumble of early industry became a full-fledged blast of technological dynamism and uninhibited development that formed and transformed Emeryville over the course of a century.

After Emeryville's incorporation in 1896, industrialists and landowners took the helm of civic government and charted the course of change. The city functioned as a tax haven and boosters touted Emeryville's tax rate as the lowest in the state, if not the entire Pacific Coast. The arrival of the AT&SF Railroad in 1904 and the relocation of industries in the wake of San Francisco's 1906 earthquake accelerated the pace of industrialization.

Following World War I, Emeryville's niche as an industrial district crystallized. The city council assisted private landowners in developing a thoroughly planned industrial park. Long, linear blocks laced with spur lines accommodated new, low-slung factories, designed for the continuous flow of assembly line production. Emeryville's new manufacturers produced everything from chemicals to automobiles. Shell Oil and Western Canning Company each constructed cutting-edge research and design laboratories. The Emeryville Industries Association was created to promote the city, solicit businesses, and, as the Congress of Industrial Organizations later observed, systematically break strikes. By the early 1940s, Emeryville's residential population remained under 2,500, while the workforce climbed to over 12,000, and industrial land uses reportedly covered nearly 80 percent of the city.

A half-century of industrialization utterly and irrevocably transformed the city. Skilled craftsmen working in small modular shops gradually gave way to assembly line workers in sprawling branch plants. Industry marched through Emeryville, razing houses and annihilating streets in order to create ever-larger industrial sites. The bay was filled with slag and refuse while engineers lined Emeryville's creeks with concrete. Bulldozers razed Emeryville's last shell mound to make way for a paint mill. As toxins poisoned Ohlone remains and artifacts, the city geared up for World War II's industrial boom.

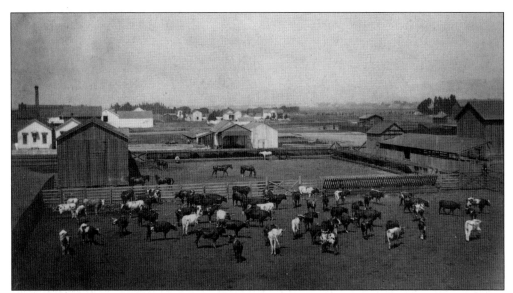

This late 19th-century view, looking north from Peabody Lane, shows the stockyards district, or "Butchertown," c. 1890. The cattle in the foreground are being watered and fattened for slaughter. The Corder's Tannery smokestack is at the top left of the photograph. (Courtesy Bancroft Library, University of California, Berkeley.)

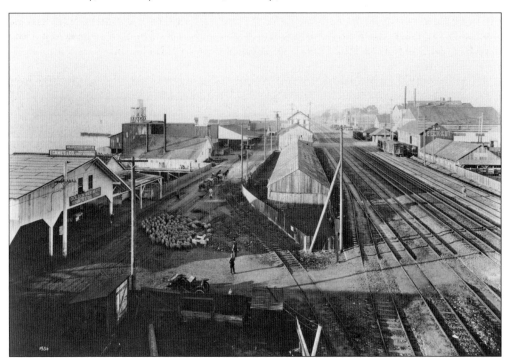

Werner Hegemann, a German city planning consultant, took this 1914 picture of Butchertown while conducting research for the City of Oakland. Golden West Meat Company and F. Cames and Company are situated on the bay shore (far left). Notice the car, the flock of sheep, and a horse-drawn meat wagon that also appear on the left. The Southern Pacific main line tracks are on the right. (Courtesy California Photo Views.)

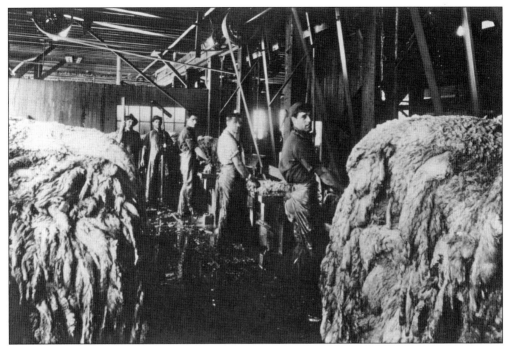

A *c.* 1890 interior shot of the T. W. Corder Wool Pulling Works and Tannery shows employees operating machinery that removed the burrs from wool and pulled the wool from the sheepskin. The wool was compressed into bales weighing 500 pounds each. The factory processed about 300,000 pounds of wool in 1887. (Courtesy Oakland Museum of California.)

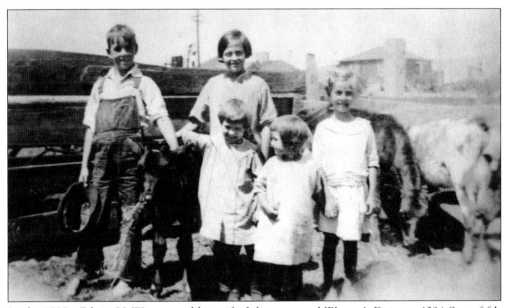

In the 1920s, Edwin V. Warren and his wife, Julie, operated Warren's Dairy at 1294 Sixty-fifth Street in the stockyards district. At this time, parts of north Emeryville, with its corrals of cattle, sheep, and dairy farms, retained a rural charm. Here, the Warren children are petting a calf on the dairy farm. (Photograph by Louis Stein; courtesy Oakland History Room.)

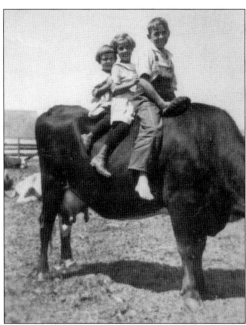

Three of Edwin V. Warren's children ride a milk cow at Warren's Dairy. The dairy shut down in the late 1920s and Warren later became a salesman. (Photograph by Louis Stein; courtesy Oakland History Room.)

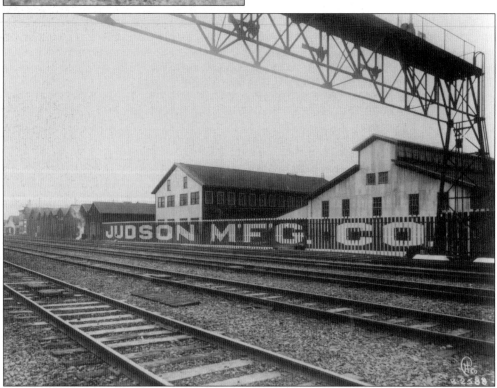

Founded by Egbert Judson in 1882, Judson Iron Works, pictured c. 1920, became one of the largest factories in Alameda County. By 1885, the plant, which was situated at the foot of Park Avenue, consisted of 28 buildings and employed a workforce of 500. Judson manufactured an array of metal products including foundry castings, spikes, bolts, rivets, nuts, and tacks. (Courtesy California Photo Views.)

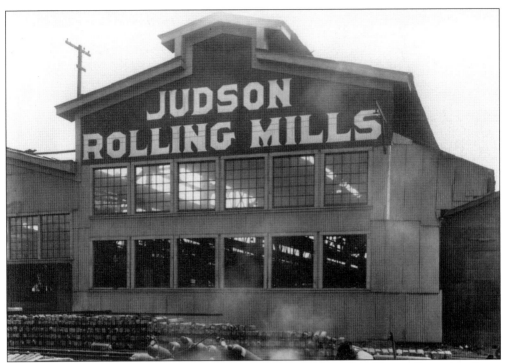

Judson Rolling Mills was part of the Judson Iron Works complex. The rolling mills produced iron bars from 18 to 40 feet in length. The iron was heated in a furnace and, when red hot, passed through rollers that changed the length and thickness. (Courtesy Oakland History Room.)

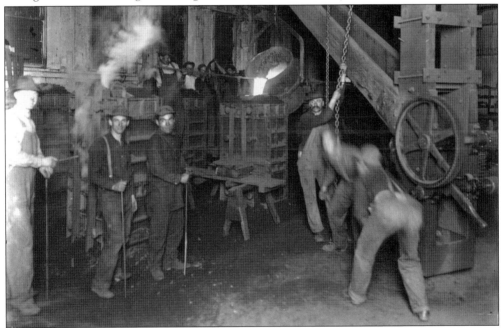

This early photograph of the interior of Judson Iron Works shows the molding room. Workers are pouring a bucket of molten steel, held in place by a crane, into a cylindrical mold. (Courtesy Oakland Museum of California.)

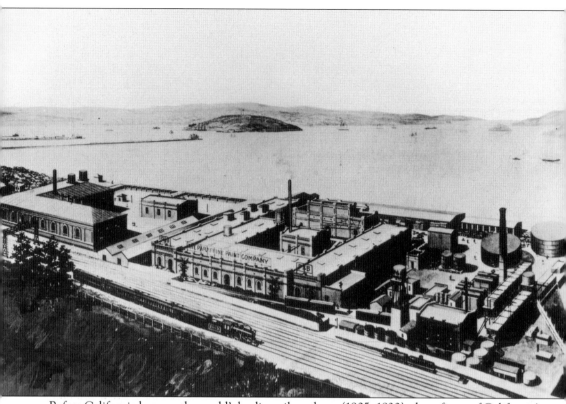

Before California became the world's leading oil producer (1905–1930), the refiners of California's petroleum were plagued with a tarry, insoluble, and seemingly valueless derivative, mistakenly called "black paraffin." In 1883, two entrepreneurs discovered that the derivative contained asphalt, an excellent waterproofing agent. They created the Paraffine Paint Company (later known as Pabco) the following year, and converted a ramshackle barn on Emeryville's shoreline into a paint and roofing material factory. A multi-year contract to waterproof local wharves preceded the unlimited demand for building materials created by San Francisco's devastation in 1906. By 1915, around the time this photograph was taken, the company had filled tidelands and constructed brick factories, an oil refinery, and one of the first felt mills in California. Stock offerings in 1919 financed the construction of the first linoleum plant in the West, which helped the company weather the Depression. By 1938, the ramshackle barn had evolved into a $10 million manufacturing complex covering 38 acres of filled tidelands. Every facet of the manufacturing process for over 6,000 products was concentrated in 11 plants at the Emeryville site, an assemblage of 155 buildings in all. (Courtesy Oakland History Room.)

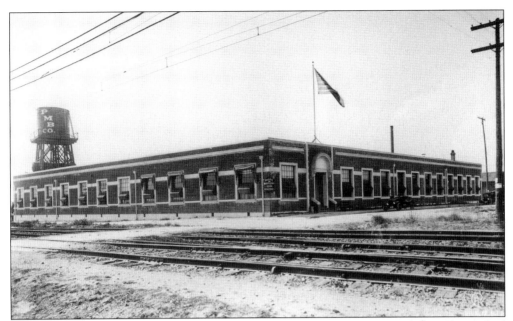

Pacific Manifolding Book Company, located at the corner of Doyle Street and Stanford Avenue, manufactured business forms, including sales books, streetcar transfers, bills of lading, delivery receipts, and commercial printing. In its heyday, the company employed 350 workers. Pictured here in 1910, the firm changed its name in 1945 to Moore Business Forms. (Courtesy *Oakland Tribune.*)

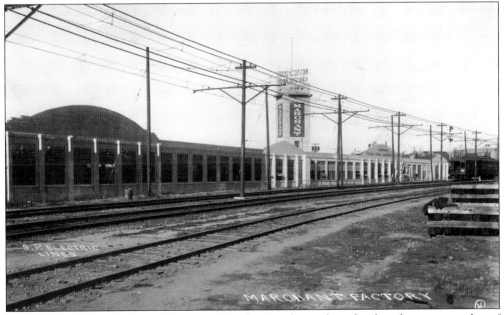

Founded in 1913 and pictured here in 1918, the Marchant plant developed into a complex of buildings that included an administrative office located at Powell and Landregan Streets and a factory at the foot of Stanford Avenue next to the Southern Pacific tracks. In 1938, Marchant employed 660 designers, workmen, and mechanics to produce its calculating machines. (Courtesy California Photo Views.)

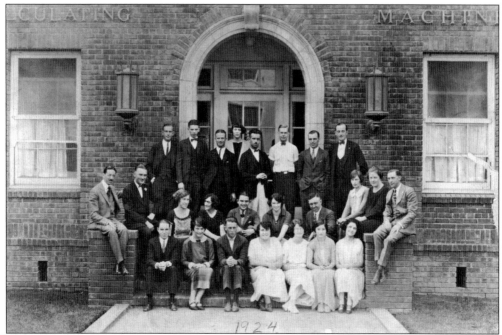

The Marchant management staff poses in front of the administrative and clerical building in this 1924 photograph. The old brick building still stands at Powell and Landregan Streets. (Courtesy Oakland Museum of California.)

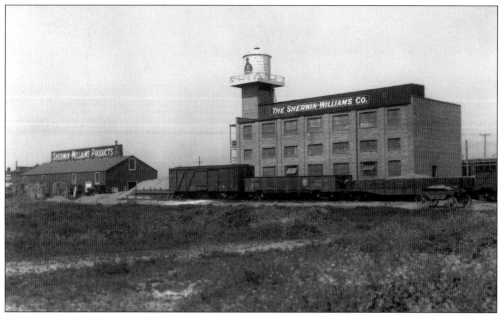

The Emeryville branch of the Sherwin-Williams paint company, pictured *c.* 1920, was built in 1919 on Horton Street next to the Southern Pacific Railroad tracks. It originally functioned as a distribution warehouse, but expanded over the years into a complex of warehouses and manufacturing plants. By the 1920s, the operation produced paints, varnishes, and insecticides. (Courtesy Oakland Museum of California.)

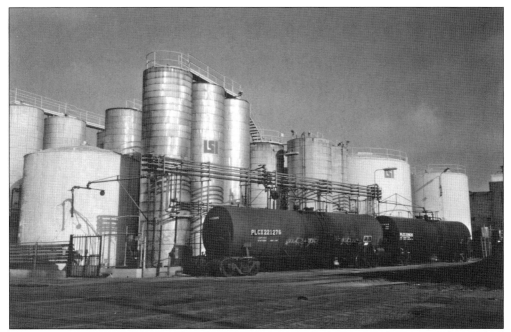

The Liquid Sugars Incorporated facility on Sixty-fifth and Sixty-sixth Streets consisted of brick buildings and a number of huge tanks. Railroad tank cars were loaded with liquid products on a spur track that connected with the Southern Pacific main line. (Courtesy Emeryville Historical Society.)

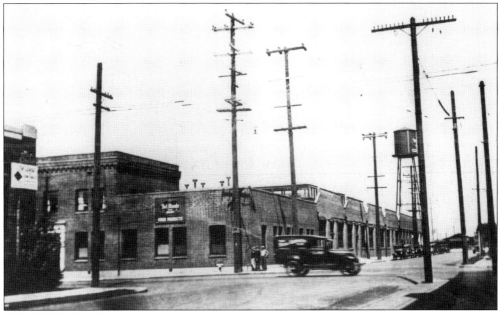

Established in 1918, Western Canning Company was located on Park Avenue between Hollis and Watts Streets. The plant expanded several times until it occupied 10 acres. Western Canning was purchased by Virden Packing Company in 1921, and then by California Packing Corporation in 1927, which later changed its name to Del Monte. This photograph was taken *c.* 1927. (Courtesy Jim Layton.)

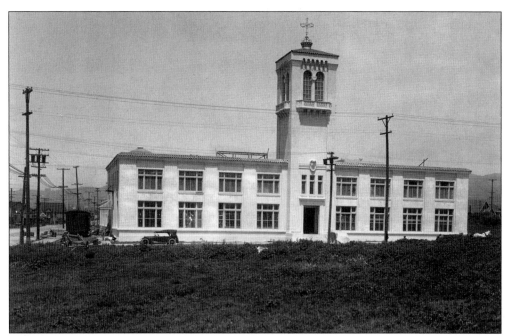

The Remar Bakery was built in 1919 on Forty-sixth Street, between Adeline and Linden Streets. The factory, pictured here around 1920, specialized in making bread and was touted as the premier baking company on the West Coast. Interstate Bakeries bought the company in 1953 and produced Sunbeam bakery products in Emeryville. (Courtesy California Photo Views.)

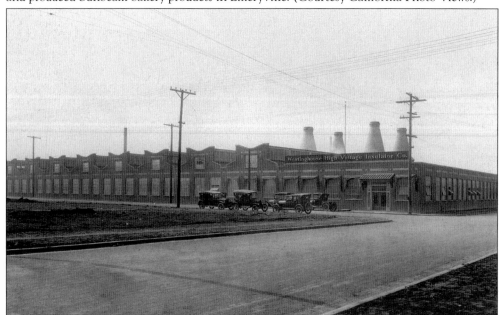

The distinctive brick factory of Westinghouse High Voltage Insulation, with its saw-tooth roof and skylights, was located at 6121 Green Street (later Hollis Street) when this c. 1920 image was taken. The plant manufactured porcelain insulators. In the process, clay was mixed with flint and spar and then molded into shapes and baked in a kiln. The factory employed 400 workers, many of them women. (Courtesy Oakland Tribune.)

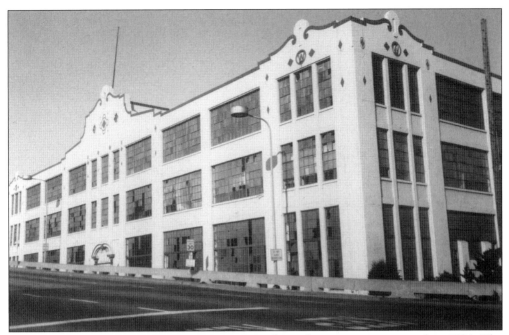

The Westinghouse Electric Corporation's regional warehouse was constructed in 1924. The concrete-frame building stood for over 75 years at Powell and Peladeau Streets, next to the Southern Pacific tracks. For several decades, the plant operated as a service and repair center for electrical equipment. (Courtesy Emeryville Historical Society.)

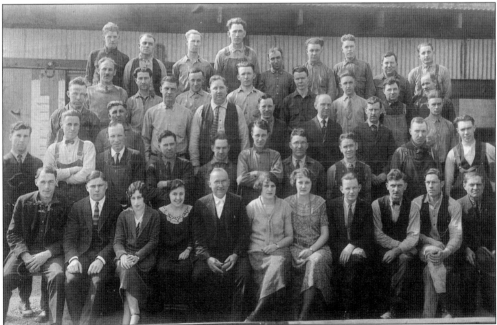

Western Electric at 1400 Fifty-third Street manufactured and repaired telephone equipment. The company also maintained a supply warehouse for Pacific Telephone and Telegraph. In 1925, when this photograph was taken, Western Electric had a workforce of 364 employees. (Courtesy Ray Raineri.)

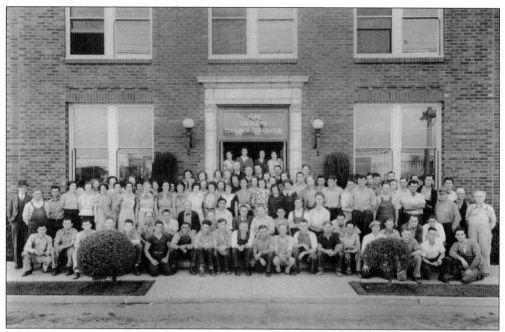

Pictured here around 1934, California Container Corporation (later Container Corporation of America) operated a plant at 4549 Horton Street. A workforce of 130 manufactured boxes and paperboard shipping containers. The spacious 80,000-square-foot facility housed heavy machinery and a large storage area for raw materials. (Courtesy Ray Raineri.)

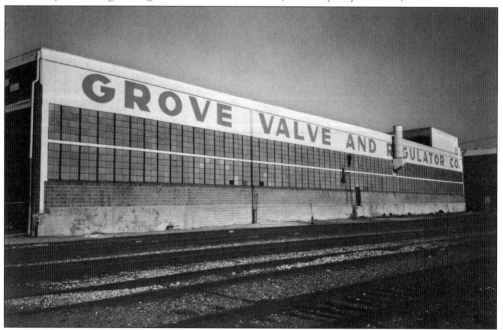

Grove Valve's sleek plant at Sixty-fifth and Hollis Streets is typical of modern utilitarian architecture. The rear facade of the plant, shown in this 1994 photograph, fronts the Southern Pacific main line. Grove Valve produced a variety of valve, flow control, and regulator equipment for handling air, gas, and steam. (Courtesy Emeryville Historical Society.)

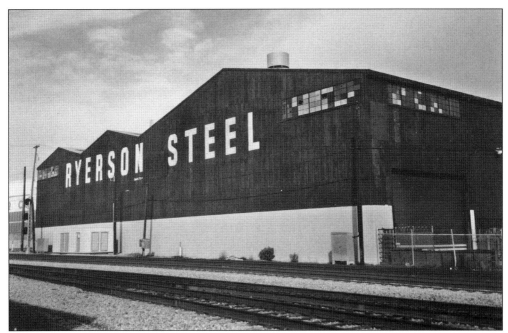

In 1946, Joseph T. Ryerson and Sons Incorporated built a 210,000-square-foot plant at Hollis and Sixty-fifth Streets. This distribution facility warehoused carbon and alloy bars, sheets, tubing, stainless reinforcing bars, babbitt metal, machinery and tools, and structural steel. The operation is pictured here in 1991. (Courtesy Emeryville Historical Society.)

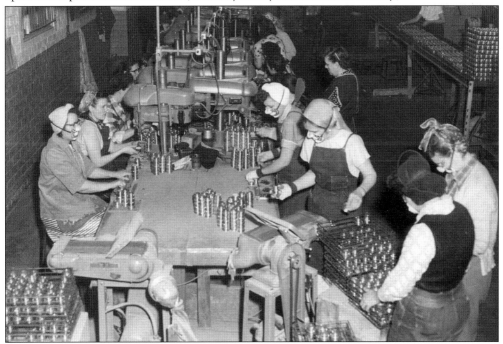

Women wearing masks and bandannas are using power tools to debur lathe-turned parts at the Albert Wright Company in 1953. This one-story brick factory was located at 4062 Hollis Street in Emeryville, just south of the old city hall. (Courtesy Emeryville Historical Society.)

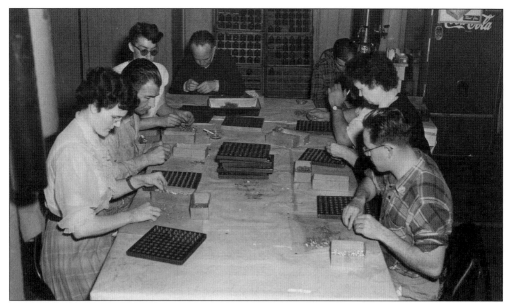

Albert Wright Screw Machine Products Company hired blind employees, because of their perceived superior dexterity, to assemble parts. Here they are working on a 1953 Korean War–era contract from the U.S. Army to manufacture three million boosters, or mechanical amplifiers, used in airplanes. (Courtesy Emeryville Historical Society.)

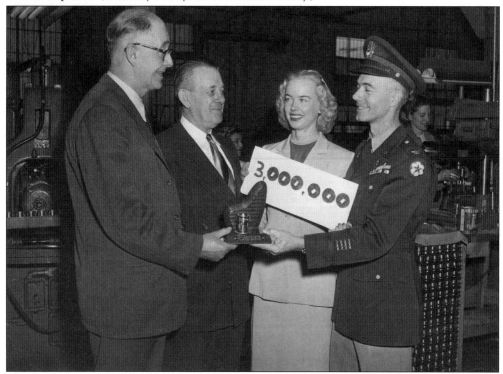

Albert Wright (left) presents the three millionth booster to an army officer in this 1953 photograph. Standing next to Wright is Chief Inspector Chuck Yarrigle. The blond woman, Helen ?, is a government inspector. (Courtesy Emeryville Historical Society.)

Five

CIVIC INSTITUTIONS
GAMBLING AND VICE

Gambling, sports, and other recreations melded into a seamless whole as Emeryville became the entertainment capital of the East Bay. Within the city's borders, different races, genders, and social classes mixed in spectacular public spaces as well as in seedy, clandestine ones. Between them a common theme endured—everyone came to play. Emeryville offered the excitement that enabled people to make a clean break with workaday life.

Fresh from California's foothills, Emeryville's pioneers imported more than profits from the gold fields. Poker clubs and saloons preceded city hall on Park Avenue, then, in 1871, the Oakland Trotting Park opened there. The track, which featured harness racing, gained national prominence when Ulysses S. Grant stood at the finish line as St. Julien set a new world's record for the mile in 1879. The real money, however, was in thoroughbred racing.

Horse-racing czar Thomas Williams Jr. renovated the track, and the newly christened New California Jockey Club opened in October 1896. A grandstand resembling a giant Chinese temple crowned Emeryville as the gambling capital of the East Bay. Underneath the sloping tiers of seats, a betting ring encircled by 20 bookmakers' stands drew gamblers from all over the region. Ribald language and bawdy behavior spilled from the track into Park Avenue's rollicking hotels, card rooms, brothels, and, of course, saloons.

The East Bay's playground was also the reformers' bedevilment. State legislation closed the Jockey Club in 1911, but gambling endured. With wires to horse racing tracks in New Orleans and Tijuana, off-track bookie joints operated in the back rooms of Emeryville's saloons and hotels. In 1919, Owen Patrick Smith briefly revived racetrack gambling in Emeryville with the construction of Blue Star Amusement Park, purportedly the first commercial dog-racing park in the West.

After Oakland cracked down on gambling in 1919, Emeryville's government opportunistically began licensing card rooms. Chinese American entrepreneurs, like their white counterparts, tapped into the lucrative vice industry. Racism made Ching Hing's Alemo Club a conspicuous target for Earl Warren's Prohibition-era raids. Yet when it came to Emeryville's speakeasies and illegal gambling clubs, Warren did not discriminate. "Vice is flourishing in Emeryville under the encouragement of city and police officials, who are getting their cut," he said. "Within a block of the police of Emeryville are 12 houses of prostitution and 20 bootlegging joints."

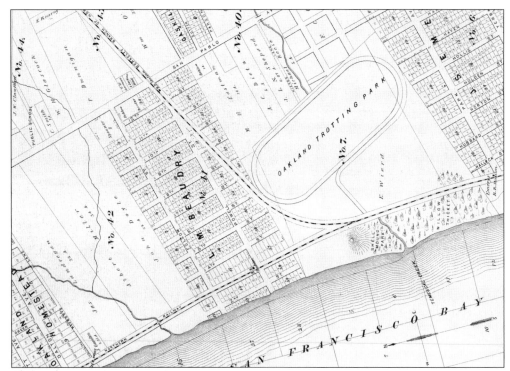

The Oakland Trotting Park, built by Edward Wiard, appears on this early map of Emeryville. The horse racetrack was located north of Park Avenue and west of San Pablo Avenue. Note the misspelling of Wiard's name. Also note Temescal Creek flowing under the track to the bay. (Courtesy Thompson & West's *Historical Atlas of Alameda County*, 1878.)

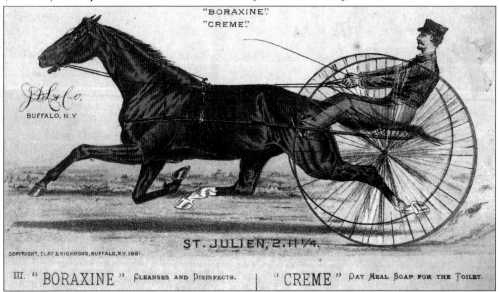

On October 25, 1879, the legendary horse St. Julien smashed the one-mile trotting record at the Oakland Trotting Park in Emeryville. On this improbable occasion, President Ulysses S. Grant, who happened to be in the Bay Area, was in the grandstand when the record was set. (Courtesy Clay & Richmond, 1881.)

Thomas H. Williams Jr. leased the Oakland Trotting Park in 1894 and thoroughly renovated the facility. The New California Jockey Club opened in 1896 and Williams continued to manage the Emeryville track until it closed in 1911. (Courtesy *Alameda County Illustrated*, 1898.)

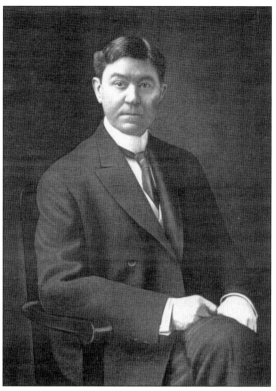

This postcard shows the New California Jockey Club grandstand, which sheltered 3,000 spectators from the elements. The 110-by-280-foot structure was constructed entirely of wood and resembled a Chinese pagoda. The horse-racing track is on the left, and a foot racetrack is on the right. (Courtesy Emeryville Historical Society.)

The New California Jockey Club's 1900 season opened on July 4 with racetrack fans dressing for the occasion. Note the elaborate hats worn by the women in the foreground. (Courtesy Oakland History Room.)

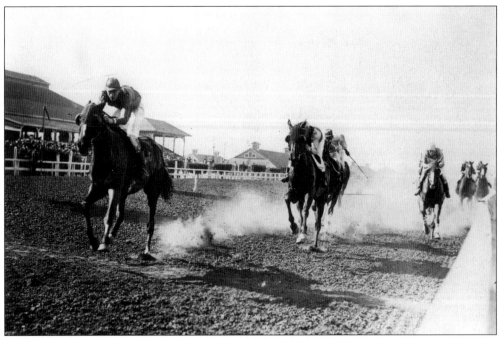

In this dramatic c. 1910 photograph, thoroughbreds are crossing the finish line at the New California Jockey Club racetrack in Emeryville. The grandstand is on the left. (Courtesy Bancroft Library, University of California, Berkeley.)

African American jockey Alonzo "Lonnie" Clayton won the Kentucky Derby in 1892 at the age of 15. He was one of the many African American jockeys who raced thoroughbreds at the Emeryville track during the 1890s. African American drivers, trainers, and grooms also worked at the track and resided in Emeryville. (Courtesy African American Museum and Library of Oakland.)

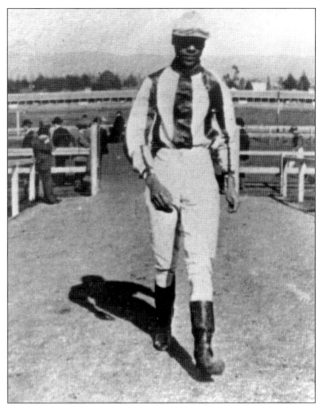

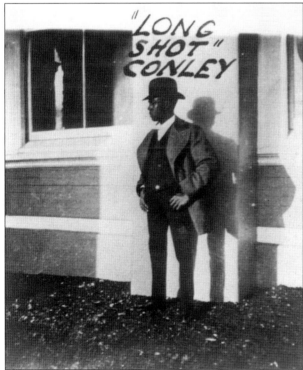

Jess "Long Shot" Conley, another African American jockey, won many races at the Emeryville track during the 1890s. In 1898, Conley defeated Ted Sloan, a famous white jockey, at the New California Jockey Club. "Long Shot" Conley placed third in the 1911 Kentucky Derby. (Courtesy African American Museum and Library of Oakland.)

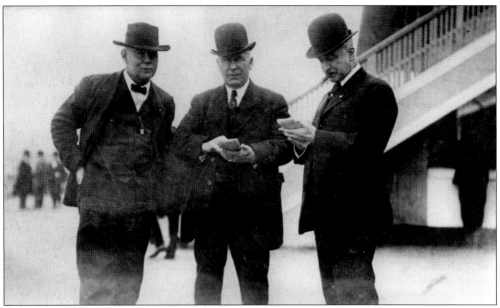

In this c. 1900 photograph, three leading Emeryville citizens compare race cards at the New California Jockey Club. Shown, from left to right, are Councilman John T. Doyle, track superintendent James Grant, and Mayor William H. Christie. (Courtesy *Oakland Tribune*.)

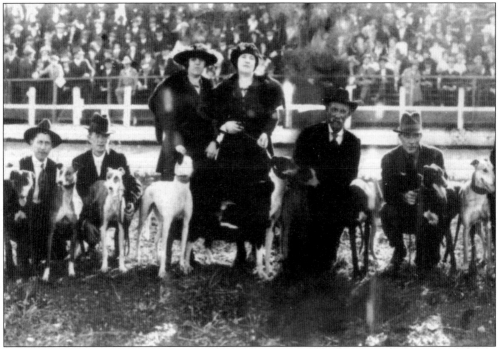

Owen Patrick Smith built Blue Star Amusement Park in 1920. The track, which was located on Park Avenue between Horton and Holden Streets, was reportedly among the first commercial dog-racing tracks in the West. Greyhounds chased a mechanical rabbit around an oval-shaped track three-sixteenths of a mile (990 feet) long, while fans bet on the winner. In this 1920 photograph, owners show off their dogs. (Courtesy Oaks Club.)

This Chinese lottery ticket from the 1920s was found in an abandoned house in Emeryville. The 80-character ticket sold for a dime and was distributed by runners, or it could be purchased at a local lottery den or gambling establishment. The Chinese lottery flourished in Emeryville during the 1930s and 1940s. (Courtesy Ray Raineri.)

In this 1925 photograph, Emeryville firefighters enjoy a friendly game of poker at the firehouse on San Pablo Avenue while kibitzers stand in the background and watch. (Courtesy Henry Lyman.)

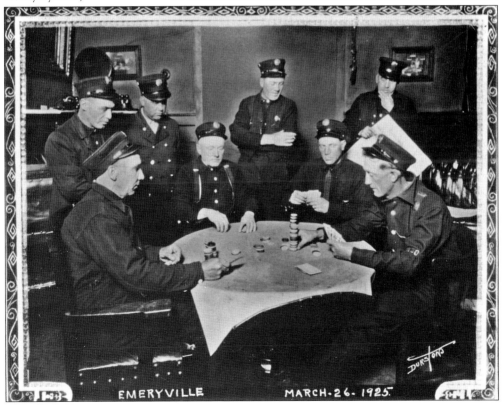

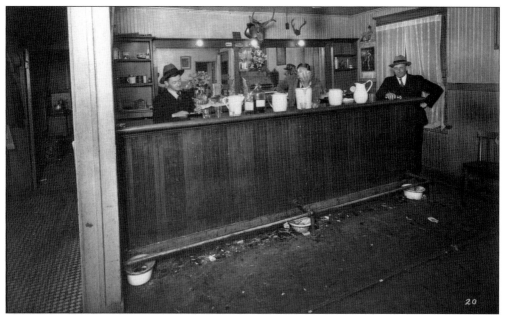

In 1930, near the end of Prohibition, agents from the Alameda County District Attorney's office raided a house at 5860 Beaudry Street that operated as a speakeasy. Inside they discovered a bar with several bottles of liquor and pitchers of beer on the counter. The cash register behind the bar provided further evidence that this was an illegal business. (Courtesy Oakland Museum of California.)

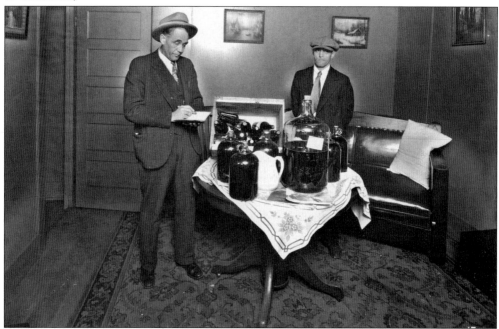

On August 9, 1930, Alameda County agents raided another house at 5928 Beaudry Street that was suspected of being a speakeasy. Sure enough, they found a room with a table covered with numerous jugs and bottles of liquor. The illegal hooch was the property of the young man on the right. (Courtesy Oakland Museum of California.)

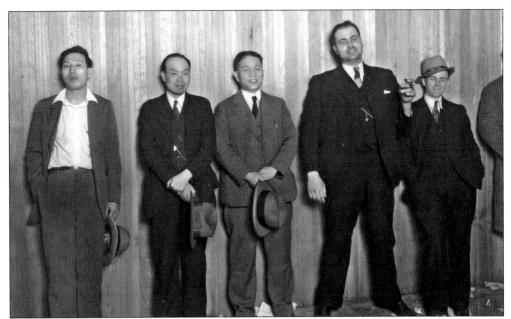

In 1931, detectives from the Alameda County Sheriff's Office raided two restaurants on Park Avenue, the United Cafe and the Watts Cafe, because they housed gambling establishments. In this photograph, five guilty looking suspects are lined up against the wall. Earl Warren was District Attorney of Alameda County during Prohibition, and he vigorously enforced laws against gambling and liquor. (Courtesy Oakland Museum of California.)

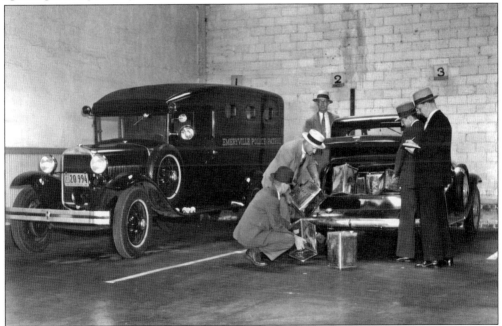

In 1932, federal agents raided the Emeryville Police Garage at 3900 Adeline Street and discovered a "liquor fleet" of five cars that contained 565 gallons of alcohol stored in five-gallon cans. Police Chief Carey said he was "shocked to know that police equipment had been consorting with a liquor fleet in the same building." (Courtesy Oakland Museum of California.)

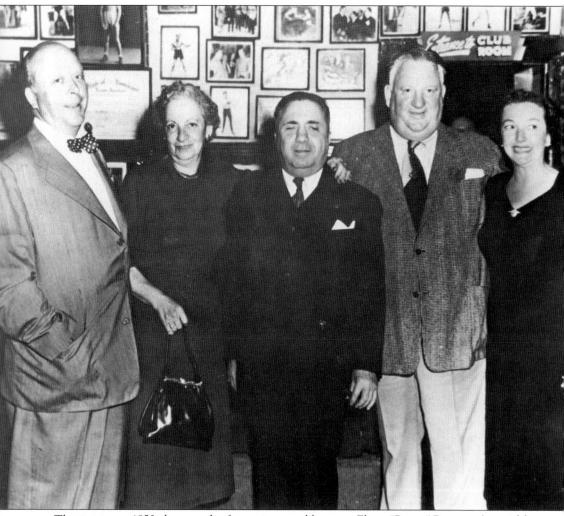

This is a rare *c*. 1950 photograph of notorious gambling czar Elmer "Bones" Remmer (second from right) and his associates at the Key Club Card Room in Emeryville. During his long career as a gangster and gambler, Remmer operated card rooms in San Francisco and in unincorporated areas of Alameda and Contra Costa Counties. While he managed the Cal-Neva Lounge at Lake Tahoe in the 1940s, the Nevada State Tax Commission warned him to "put square dice and new decks on the table." In the mid-1950s, Remmer attempted to open a card club at the La Rue Restaurant on the first floor of the Ritz Hotel in Emeryville, but was thwarted by the city council. He was subsequently sent to prison for income tax evasion. After serving his sentence, Remmer sold used cars for his brother William, who was the co-owner of a car lot in Oakland. When Bones died in 1963, the underworld mourned the loss of the "big daddy of Northern California gambling."

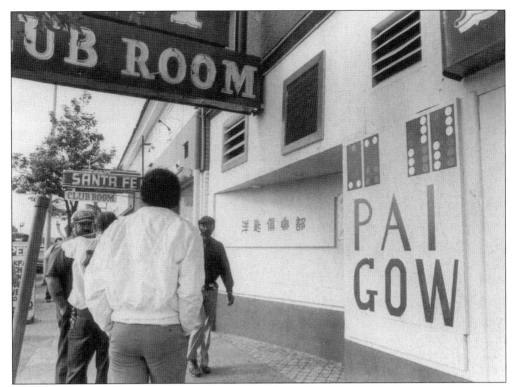

The Key Club (right) and the Santa Fe Club were located on San Pablo Avenue north of Yerba Buena Avenue. The Key Club was the first Emeryville club to offer pai gow, a Chinese game played with 32 domino-like tiles. The Santa Fe Club closed around 1987 and reopened in 1989 as the King Midas Club. This photograph was taken in 1985. (Courtesy *Oakland Tribune.*)

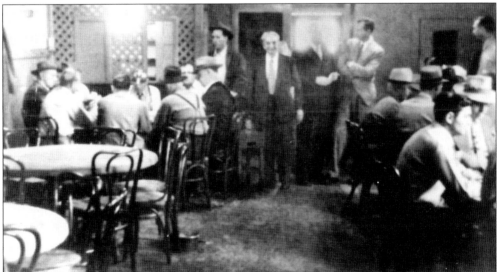

Today Oaks Card Club endures at the corner of San Pablo and Park Avenues. The original structure, built in the late 1890s, has been expanded and modernized. This photograph from the late 1930s shows manager Tony Esnola standing in the center of the smoky club. Today the club is the last vestige of Emeryville's gaming past. (Courtesy Oaks Club.)

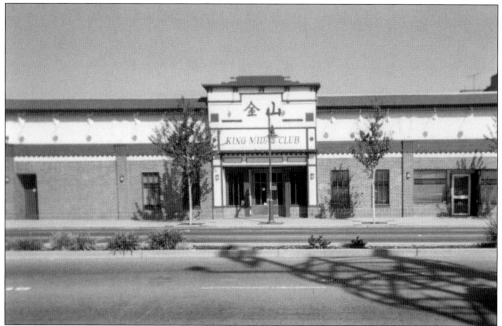

The King Midas Club and Restaurant, pictured here in 1998, was located at 3992 San Pablo Avenue near Fortieth Street in a building formerly occupied by the Santa Fe Club. The King Midas Club (1989–1997) catered to a Chinese American clientele. (Courtesy Emeryville Historical Society.)

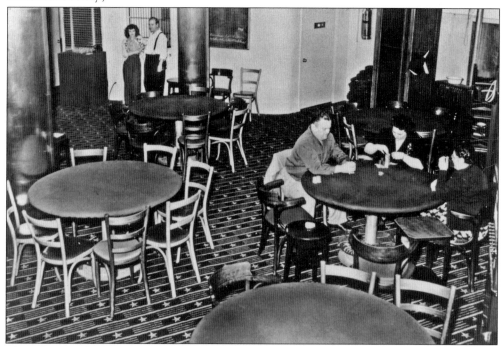

This photograph shows the interior of the Avalon Club in the mid-1950s. The Avalon was located in the first floor of the Ritz Hotel, a three-story brick building at 3872 San Pablo Avenue. It was the first club in Emeryville to admit female card players. (Courtesy Oaks Club.)

Six

BIPLANES AND BASEBALL
SPORTS

After horse racing was outlawed, Emeryville's sports took center stage. During the years preceding World War I, racing at Emeryville's New California Jockey Club changed from horses to horsepower, and spectators' perceptions of time and space were transformed. Airplane racing and aerial acrobatics introduced Bay Area residents to the promise and peril of aviation. A small cadre of international aviators converged in Emeryville, with Lincoln Beachey as the biggest star. Master of the loop-the-loop, he was considered not only a daredevil, but also the master of a sublime art form.

Flat-track motorcycle racing provided a welcome diversion during the Depression. Four thousand spectators packed the Emeryville Speedway in 1933, as brakeless motorcycles spun out, careened into fences, and piled up. By 1935, open cockpit cars powered by motorcycle engines ruled the track. But the midget-car racers' reign was short-lived; the Emeryville Speedway closed in 1937.

Compared to fleeting forms of racing, America's pastime stood the test of time in Emeryville. The Pacific Coast League was formed in 1903 with teams in Sacramento, Los Angeles, Portland, San Francisco, and Oakland. After winning the pennant in 1912, the Oakland Oaks baseball team celebrated by building a new ballpark in Emeryville. Wedged between factories, stores, bars, and houses on the northwest corner of Park and San Pablo Avenues, Oaks Ball Park accommodated 10,000 fans. Russell "Buzz" Arlett, a switch-hitting pitcher and outfielder, was the loyal fans' favorite. The Oakland native joined the Oaks in 1918, and his 13-year career included a 1927 championship.

A squad of veterans known as the "Nine Old Men" led the Oaks to a pennant in 1948. The Oaks broke the color line the following year by signing Artie Wilson, a standout shortstop for the Birmingham Black Barons. An instant fan favorite in Emeryville, Wilson won the Pacific Coast League batting championship and led the league in stolen bases in 1949. A victory parade followed the Oaks' 1950 season, but revenues and attendance began to slip. As the momentum of sports in Emeryville sputtered, the Oaks' owners promoted auto races at the ballpark. The races failed and Emeryville's sports came to a screeching halt. In 1955, the Oaks were sold and moved to Vancouver, British Columbia.

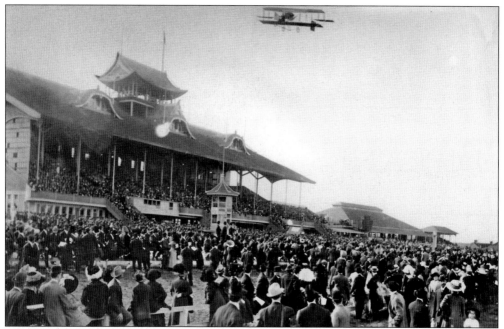

The Third International Aviation Meet was held in February 1912 at the old Emeryville horse racetrack. The famous aviators of the era participated in this eight-day event, including Lincoln Beachey, Blanche Scott, Farnum Fish, and Tom Gunn. In the photograph above, the intrepid Lincoln Beachey soars over the grandstand. (Courtesy Louis Stein.)

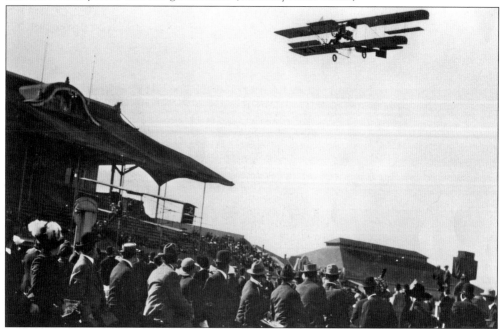

A biplane hovers near the grandstand of the California Jockey Club racetrack in Emeryville, while the spectators gawk in wonder. Several airplanes crashed because of windy weather but no one was killed, and the 30,000-plus crowd applauded the show. (Courtesy Bancroft Library, University of California, Berkeley.)

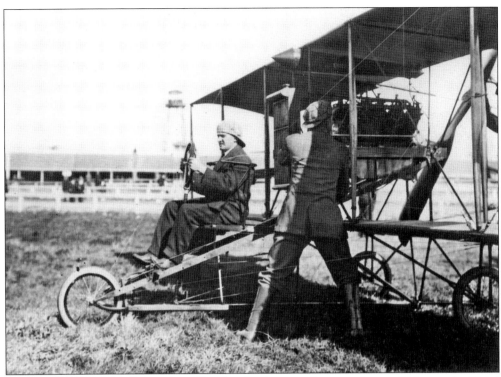

In February 1912, Lincoln Beachey, "the daredevil aviator," executed stunt flights at the Third International Aviation Meet in Emeryville. Eschewing aviator gear, Beachey always wore a suit and a golf cap when he flew, reversing the golf cap just before take off. (Courtesy Bancroft Library, University of California, Berkeley.)

Lincoln Beachey (left) and Barney Oldfield pose for a photograph in 1914 at the Emeryville track before their famous aero-auto race. Newspaper reporters called the race between a biplane and an automobile a "death sport" because of the inherent danger of the contest. (Courtesy Bancroft Library, University of California, Berkeley.)

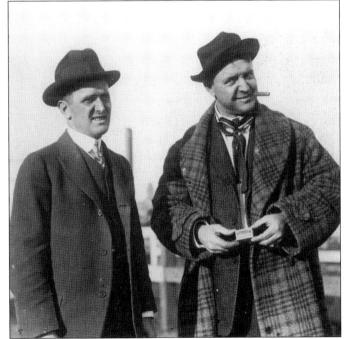

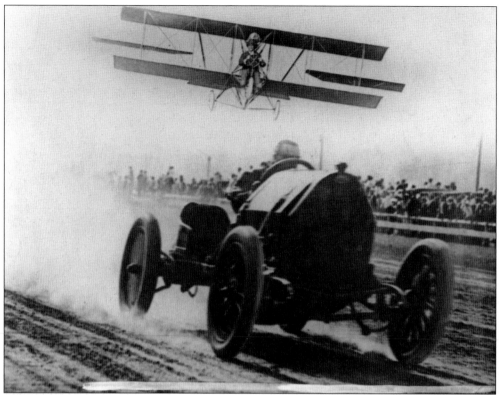

On January 10, 1914, Lincoln Beachey, flying a Curtiss biplane, raced Barney Oldfield, driving a Simplex racer, at the old Emeryville track for the "speed championship of the universe." The race ended in disaster when Beachey nosedived into the track. The biplane was seriously damaged, but the intrepid birdman survived the crash. (Courtesy Oakland Museum of California.)

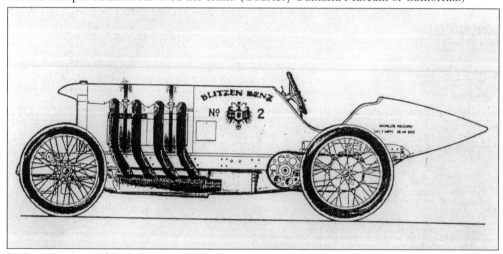

In June 1913, "Wild" Bob Burman raced the Blitzen Benz No. 2 at the Emeryville track. The Benz covered the one-mile course in 50 seconds flat with an average speed of 72 miles per hour, shattering the old record by six seconds. In August 1914, Teddy Tetzlaff, driving the same vehicle, challenged the land speed record at the Salduro Race Course in Utah. (Courtesy Robert Rampton.)

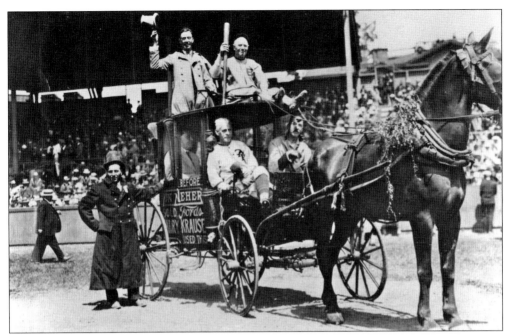

A local Ford Motor Company dealership's horse-drawn carriage makes a surprise appearance at the Oaks Ball Park, *c.* 1927. Three baseball players appear to be riding in the vehicle, one holding a bat on top and two sitting up front. The grandstand is filled to capacity with fans. (Courtesy Oakland Museum of California.)

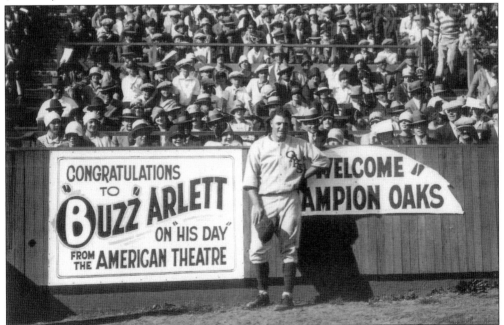

When the Oakland Oaks won the pennant in 1927 with a record of 120 wins against 75 losses, the team held a special event in honor of brilliant outfielder Russell "Buzz" Arlett. The Oaks had to wait 21 years before they won another pennant in 1948. (Courtesy Emeryville Historical Society.)

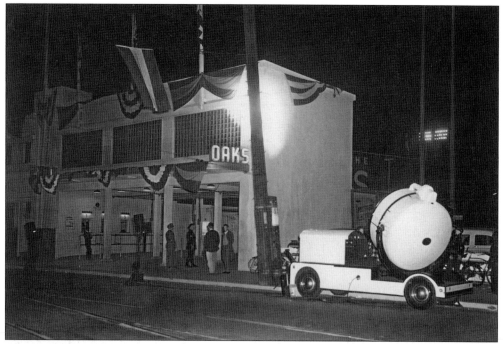

In a dramatic attempt to promote a night game at the Oaks Ball Park, the management illuminated the sky with a searchlight and decorated the main entrance with banners for this *c.* 1940 game. (Courtesy Oakland Museum of California.)

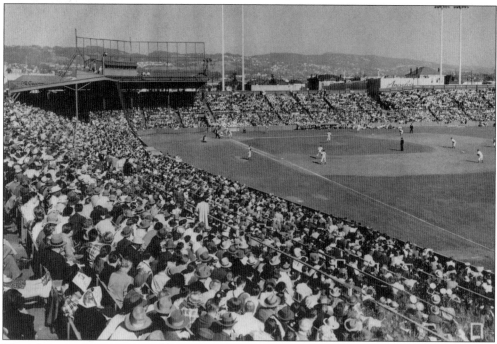

This photograph is a memorable image of a 1948 game underway at the Oaks Ball Park in Emeryville. The shot was taken from the first base-side grandstand, looking southeast. (Courtesy Emeryville Historical Society.)

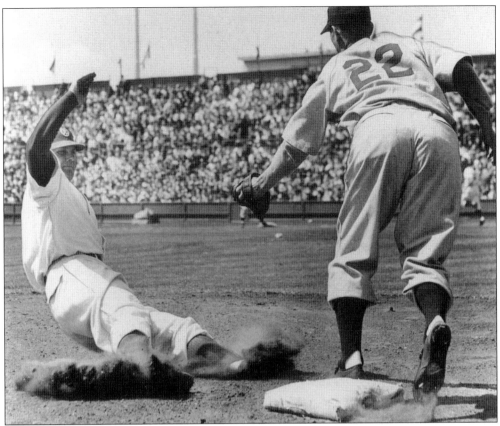

Oaks player Nick Etten is thrown out at third base in the fourth inning of a 1948 game with the Los Angeles Angels. The Los Angeles third baseman is Albie Glossop. The Oaks won the game 2-0. (Courtesy Oakland Museum of California.)

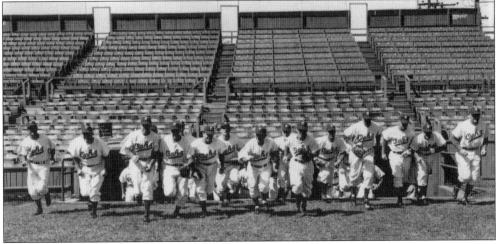

Oaks coach, George Kelly (far right), leads the team charge from the dugout for the pregame warm-ups in this 1948 photograph. The dugout was on the first base side of the Oaks Ball Park. The wooden steps in the stands appear to be well worn. (Courtesy Emeryville Historical Society.)

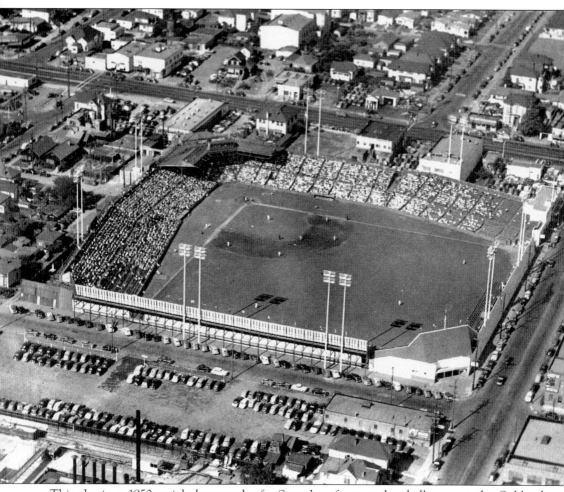

This classic *c.* 1950 aerial photograph of a Saturday afternoon baseball game at the Oakland Oaks Ballpark shows the configuration of the stadium. San Pablo Avenue runs horizontally at the top, and Park Avenue is on the far right side. The park shut down in 1955 and the team moved to Vancouver, British Columbia. (Courtesy Ray Raineri.)

The Walk-A-Thon arena opened in 1932 in an abandoned factory on Park Avenue. In this sport, competitors wearing athletic attire walked in teams of two around a track hour after hour. The team that completed the most laps won the contest. The cover at right appeared on a 1933 Walk-A-Thon program. (Courtesy Ray Raineri.)

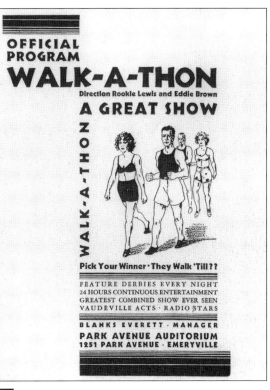

This is a 1935 promotional photograph of the young, handsome "Rookie" Lewis, master of ceremonies of the Walk-A-Thon contests. He also broadcast the marathon races on radio station KTAB. The grueling Walk-A-Thon contests went on 24 hours a day, accompanied by an orchestra and vaudeville acts. (Courtesy Emeryville Historical Society.)

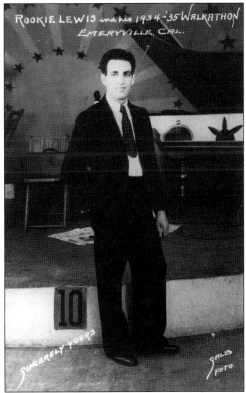

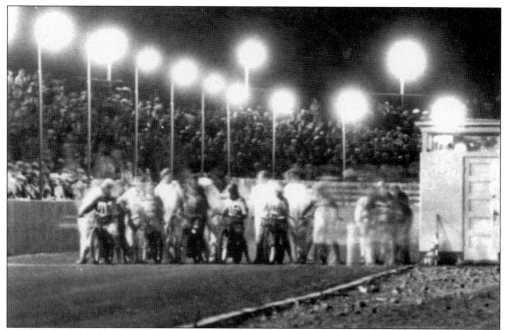

The motorcycles are lined up and ready to race on opening night at the Emeryville Speedway, June 27, 1933. The one-fifth-mile track was located at Forty-seventh Street and San Pablo Avenue. For several years, the track featured both motorcycle and midget-car racing. The grandstand had a capacity of 4,000 spectators. (Courtesy Oakland Museum of California.)

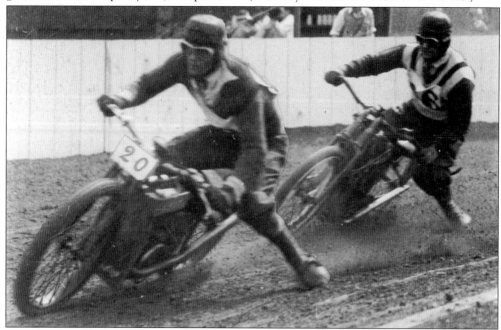

In a 1933 race, Dick Springston (left) and Al "Muzzy" Esposito have only inches separating their motorcycles as they careen around the corner at high speed before shooting down the straightaway. From 1933 to 1936, flat-track motorcycle racing was featured at the Emeryville Speedway. (Courtesy Oakland Museum of California.)

Bo Lisman leads the pack in a 1933 race at the Emeryville Speedway. Flat-track motorcycle racing was inherently dangerous because of the terrific speed of the vehicles, which had no brakes. (Courtesy Oakland Museum of California.)

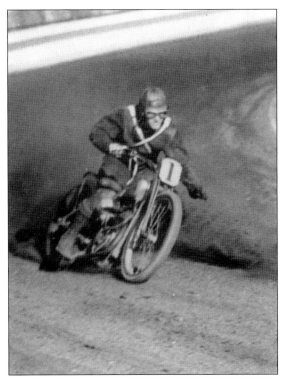

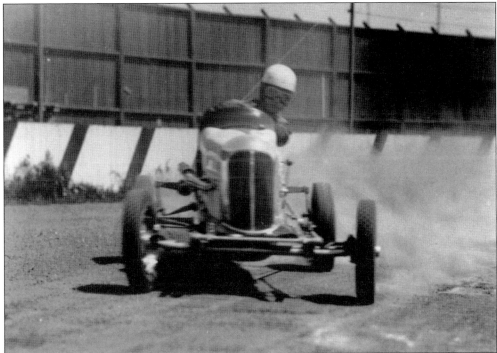

Freddie Agabashian pilots Scotty Hovey's Indian at the Emeryville Speedway in 1937. In the 1930s, midget racing cars were powered by motorcycle engines, and the bodies were hand-crafted from sheet metal. (Courtesy Doug Shaw.)

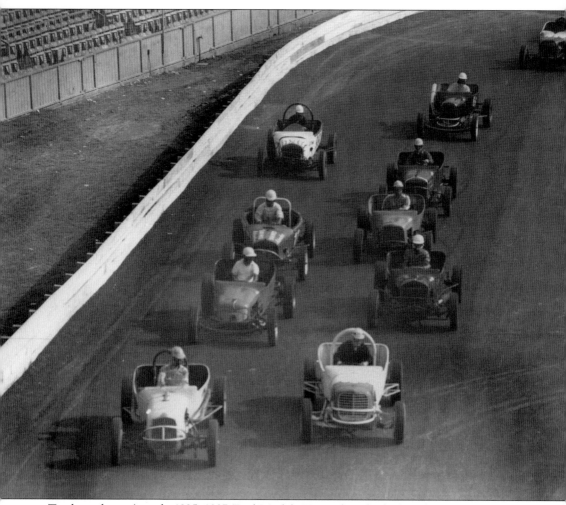

Track roadsters (mostly 1925–1927 Ford Model "T" roadster bodies) jockey for position at the starting line on the asphalt track at the Oaks Ball Park in Emeryville. This main-event race was held on September 20, 1953. The experiment to introduce auto racing events at the ballpark failed when the expected crowds did not materialize. (Photograph by Russ Reed; courtesy Jim Chini.)

Seven

GREAT ESCAPES
RECREATION AND DINING

Emeryville's small stretch of shoreline exerted a centripetal force. The Ohlone arrived first and created massive shell mounds. The Californios came next and enclosed the area to corral prodigious herds of cattle. By the 1870s, the new Californians gathered on Emeryville's shoreline and created their own history.

It started in 1876, when Edward Wiard built a rifle range across the railroad tracks from the Oakland Trotting Park. The Oakland Guard came for target practice. A shady willow thicket attracted the employees of San Francisco's Palace Hotel for a picnic. Then Wiard crowned the sole remaining shell mound with a dance pavilion. The prospect of waltzing on an Indian burial ground only added to the titillation as Shell Mound Park was born. In 1878, the Workingmen's Party held a rally and vitriolic chants of "The Chinese Must Go" reverberated. In 1922, the House of Ruth, a female African American chapter of the Odd Fellows, held their annual picnic. In between, all types of unions, clubs, and societies gathered at Shell Mound Park: the Butchers' Association, the Swedish Society, the Catholic Ladies Aid Society of Oakland, and the Golden Gate Literary Society, just to name a few.

Excursions to Shell Mound Park were typically a daylong affair. San Franciscans put on the latest styles and rode the ferry to Oakland's Long Wharf or the Key Route Pier, where they met East Bay picnickers on trains and trolleys bound for Shellmound Station. The picnics started at noon. With orchestras offering music, and beer gardens providing courage, dancing commenced in the early afternoon. A bugle sounded as activities began at "the athletic park." Foot and bicycle races included all attendees: boys, girls, and "married ladies" with long dresses delicately pulled above their ankles. "Fat men" and "fat ladies" competed for prizes ranging from cigars to a half-ton of Wellington coal. The day ended with more dancing, concerts, and moonlit walks. The crowds subsided after Prohibition and Shell Mound Park closed in 1924.

In the 1930s, people gathered in Emeryville to celebrate a mythic past during Pioneer Days. In the 1940s and 1950s, a motley crowd of industrial workers, commuters, gamblers, military personnel, baseball fans, and street hustlers congregated in San Pablo Avenue's honky-tonk district. All the while, Park Avenue endured as a red light district offering a glut of lottery dens, bordellos, and night clubs, as well as restaurants and bars.

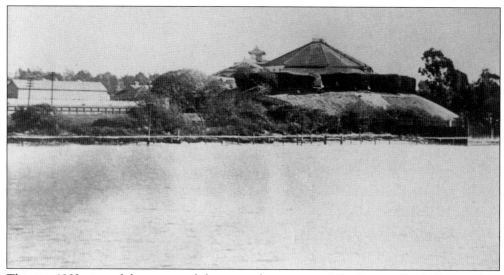

This is a 1902 view of the octagonal dance pavilion on top of the Emeryville shell mound, as seen from the bay. One of the main attractions at Shell Mound Park was the pavilion. Built in 1877 by Edward Wiard, it measured 90 feet in diameter. While the band played, dancers waltzed across the floor, perhaps unaware they were dancing over the bones of dead Native Americans. (Courtesy Phoebe Apperson Hearst Museum of Anthropology and the Regents of the University of California.)

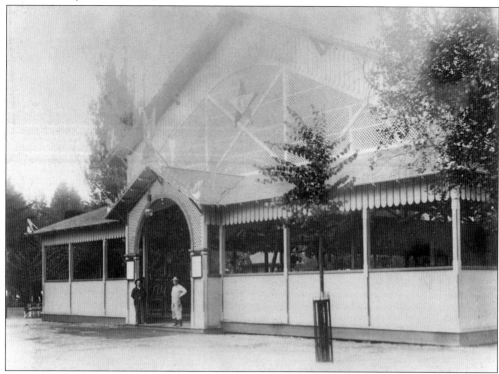

Shell Mound Park boasted two dance pavilions—one on top of the shell mound and another on level ground. The latter, pictured above in 1908, had a gabled roof and was open on all four sides. Both were equipped with a bar. (Courtesy Oakland Museum of California.)

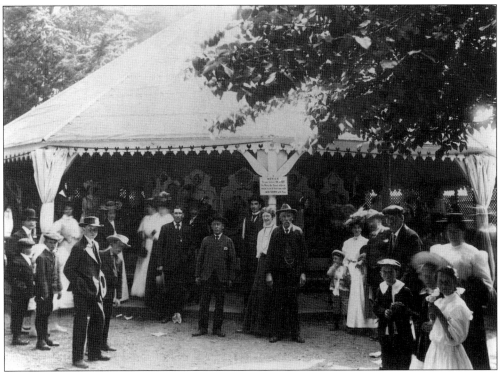

The Shell Mound Park carousel, shown in this 1907 photograph, was one of the many attractions in the 16-acre park that drew thousands of pleasure seekers each weekend during the picnic season. Shell Mound Park operated from 1876 to 1924. (Courtesy Oakland Museum of California.)

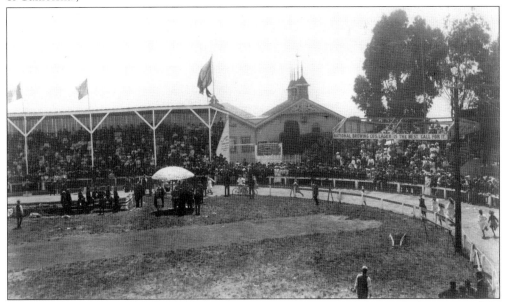

Shell Mound Park featured a grandstand seating 3,000 spectators and a track that was used for foot and bicycle races. In this c. 1908 photograph, young girls (on right) are running around the track while the audience cheers. (Courtesy Oakland Museum of California.)

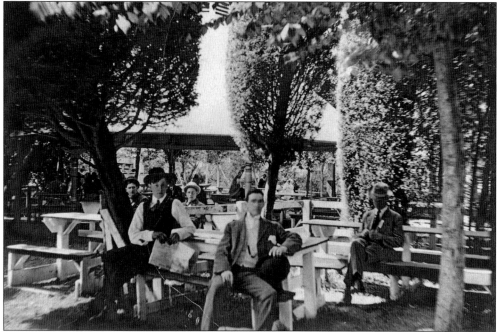

Young men, dressed in the latest styles, sit on benches under the trees in the picnic area enjoying a summer's day at Shell Mound Park, *c.* 1900. A pavilion can be seen in the background. (Courtesy Oakland Museum of California.)

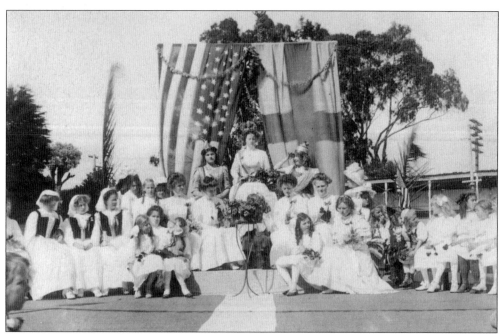

This 1909 picture postcard captures a Swedish festival held at Shell Mound Park. American and Swedish flags hang in the background. Women dressed in folk costumes are sitting on the left, flower girls appear on the right, and the May Queen sits on a throne in the center. (Courtesy Oakland History Room.)

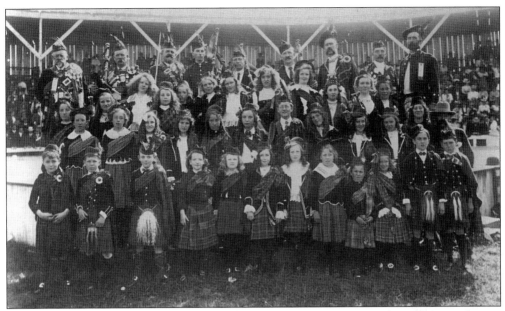

Members of the Caledonian Club, wearing their Scottish tartans, pose for a photograph on a festive afternoon at Shell Mound Park. Lodges, clubs, and union organizations gathered at the park, lured by the tree-covered picnic grounds, restaurant, beer garden, and the many other attractions. (Courtesy Oakland Museum of California.)

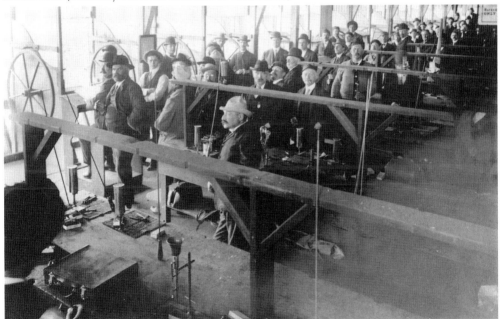

Shell Mound Park originated in 1876 as a 200-yard rifle range. Additional pistol and rifle ranges were soon added, and the park gained popularity with sportsmen and militia. By the late 1880s, major interstate shooting matches were held at the park. In July 1901, the National Shooting Bund Competition at Shell Mound Park attracted sharpshooters nationwide. Although this c. 1910 photograph depicts a welter of men, in 1896 the Columbia Pistol and Rifle Club allowed women to participate in its shooting excursions at the park.

After the closing of the horse racetrack, the vacant property served as a venue for a 1915 circus. The old California Jockey Club grandstand can be seen in the background. (Courtesy California Photo Views.)

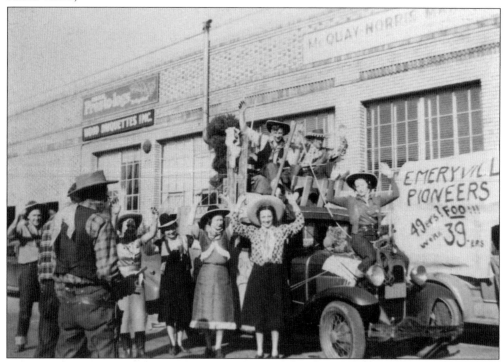

In this February 25, 1939, photograph, a gunslinger (left) with a bandanna over his face holds up the passengers of a Model A Ford stagecoach on the 4200 block of Hollis Street. The Pioneer Day festivities in Emeryville coincided with the opening of the Golden Gate International Exposition on Treasure Island, which celebrated the completion of the San Francisco-Oakland Bay Bridge and the Golden Gate Bridge. (Courtesy Ray Raineri.)

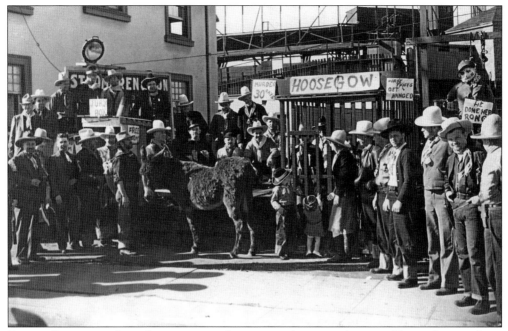

Emeryville pioneers dressed in western garb prepare to hang murderers and horse thieves after a mock trial in this 1939 photograph. The jury box is the on left, a jail (hoosegow) is in the center, and a hanging dummy is on the right. The Emeryville Fire Department appears on the left, and the backstop for the Oaks Ball Park looms in the background. (Courtesy Ray Raineri.)

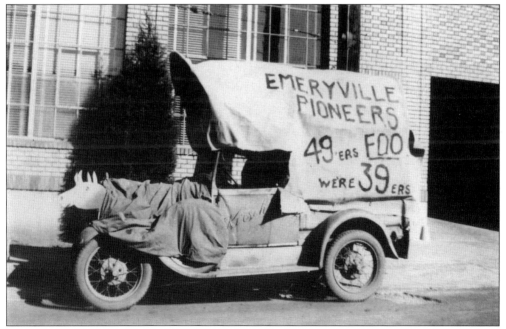

On Pioneer Day in Emeryville, residents celebrate the opening of the Golden Gate International Exposition by dressing as cowboys and cowgirls. In an effort to recreate the Wild West era, old automobiles were converted into stagecoaches and covered wagons. Notice the fake horse heads that are attached to the front of a pickup truck on Hollis Street. (Courtesy Ray Raineri.)

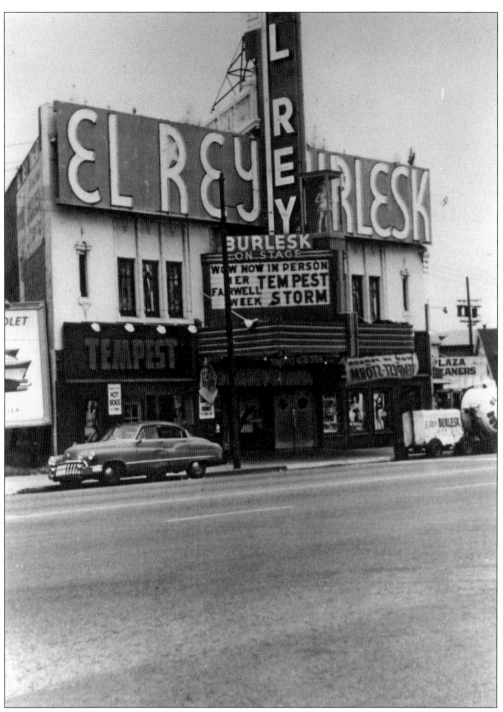

The El Rey Burlesque Theater, shown here in 1956, was located on San Pablo Avenue near Thirty-fifth Street in North Oakland next to the Emeryville line. It opened in 1927 as the Plaza Theater, a legitimate theater with stage productions. It was converted into a movie theater in 1930, renamed the El Rey in 1939, and became a burlesque theater in 1949. In 1956, the El Rey featured Tempest Storm, the Queen of the Strippers. (Courtesy California Photo Views.)

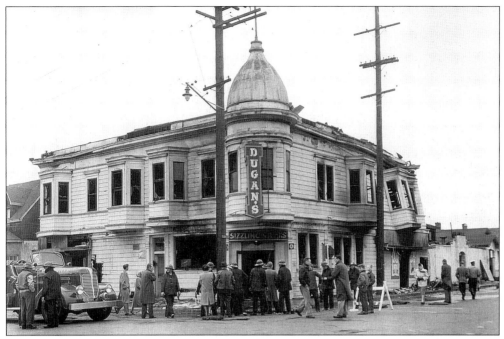

Dugan's Hotel and Restaurant was built after the turn of the 19th century at the northwest corner of Hollis Street and Park Avenue. The restaurant and bar became a hangout for turfmen and jockeys during the racetrack era. It featured Gay 90s variety shows, dancing, and hobbyhorse races in the 1940s. The building was destroyed by fire on February 7, 1949. (Courtesy *Oakland Tribune*.)

In this *c*. 1946 photograph, two couples are enjoying the dining experience at Dugan's Restaurant. A roving photographer took pictures of patrons and sold them as souvenirs. In the background is the bottom left corner of a painting of the famous race between Lincoln Beachey, flying an airplane, and Barney Oldfield, driving an automobile, that took place at the Emeryville Race Track in 1914. (Courtesy Emeryville Historical Society.)

Originally a bootlegging joint, the rustic building at 5862 Doyle Street opened as Vernetti's Townhouse in 1936, a bar and restaurant named after the proprietor, Joe Vernetti. Pictured here around 1970, it became a popular hangout for local politicians in the decade that followed. (Courtesy *Oakland Tribune*.)

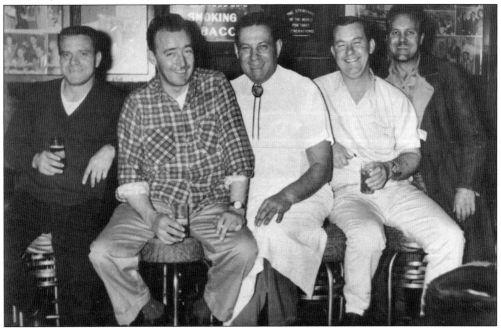

In this *c.* 1950 photograph, four jovial customers and the owner are enjoying stiff drinks at the Townhouse bar. "Ski" Cyhbusky is on the left and Joe Vernetti sits in the center. Vernetti sold the restaurant in 1977, and it later became a western bar. Another transformation occurred in 1989 when, under new management, the old building was remodeled and converted into an upscale restaurant. (Courtesy Emeryville Historical Society.)

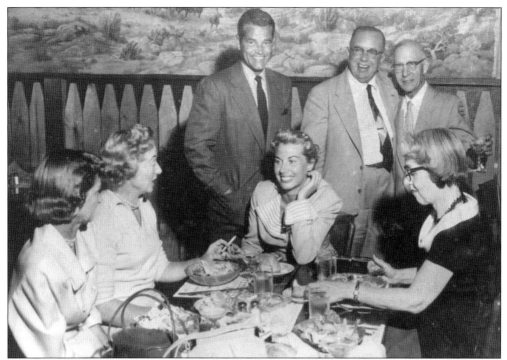

In a candid scene from the early 1950s at Vernetti's Townhouse, three men flirt with ladies sitting at the table. The mural in the background is a western scene with horses pulling a covered wagon. (Courtesy Emeryville Historical Society.)

Ravazza's Restaurant at 4073 San Pablo Avenue, shown here in the mid-1950s, opened in the late 1940s. Operated by Jack Ravazza, the restaurant specialized in Italian cuisine, including pizza. The business was equipped with a bar, and to entertain customers, Jack played tunes by tapping a spoon on glasses that contained various amounts of liquid. The building to the left is the Corona Club Cardroom.(Courtesy Oaks Club.)

Eugene's Ranch House Restaurant opened in 1964 in a building that was originally a gas station at the corner of Hollis Street and Park Avenue. The business, owned by Chinese immigrant Eugene Yee, catered to factory workers from Del Monte and Judson Steel. The restaurant, pictured here in 1990, closed in 2002, but later reopened under new management as Rudy's Can't Fail Cafe. (Courtesy Emeryville Historical Society.)

After the Ranch House shut down, Jeffrey Bischoff renovated the building and converted it into an upscale "retro" diner, improbably named Rudy's Can't Fail Cafe. The name was taken from a line in a song by the British punk band, the Clash. Since the local factories have shut down, the new cafe, pictured here in 2004, appeals to an emerging yuppie clientele. (Courtesy Emeryville Historical Society.)

Eight

THE STRIPS
SAN PABLO AND PARK AVENUES

San Pablo and Park Avenues have molded and mirrored Emeryville's history. With its genesis as the Californios' thoroughfare, San Pablo Avenue is the oldest road in the East Bay. Known as Contra Costa Road during the gold rush, it was advertised as the main wagon route towards Sacramento and the gold fields. In 1852, the Alameda County Board of Supervisors renamed it San Pablo Avenue and a stream of horse-drawn stagecoaches, buggies, and wagons traversed early Emeryville. By the 1870s, Joseph Emery and other prominent families had built show-place estates on the avenue. Emeryville's early schools and fire station were also located on this main street. At the turn of the century, Key Route trolleys brought a new wave of development. A bustling commercial strip emerged, consisting of the Oaks' baseball park, hotels, general stores, restaurants, banks, a train station, and a movie theater. During the 1920s, cardrooms, saloons, restaurants, and cigar stores overtook San Pablo Avenue. Then the construction of gas stations, car dealers, and the East Bay Auto Camp heralded the ascendance of the automobile. During the 1930s and 1940s, San Pablo Avenue reached its height as Emeryville's main drag. But during the 1950s, the trolleys and trains ceased operation, and the Oaks Ball Park closed. San Pablo Avenue declined into a tattered strip.

The development of Park Avenue, a half-mile street connecting San Pablo Avenue to the shoreline railroad tracks, took a different route. Named for the Oakland Trotting Park, Park Avenue's early hotels, restaurants, saloons, and brothels catered to the racetrack crowd. Many of Emeryville's early residents found housing in Park Avenue's boarding houses and residential hotels. After years of meetings in the Commercial Union Hotel, located at the foot of Park Avenue, the city council moved up the street to Emeryville's new city hall in 1903. When California legislation outlawed horseracing in 1911, the red-light district transformed into an industrial corridor. Several furniture companies built warehouses on Park Avenue, near the Southern Pacific tracks. Then a new American Can Company warehouse overtook an entire block. Soon, brick-faced factories eradicated old stables, houses, and hotels.

By the 1970s, Emeryville's two main streets had met the same fate. Most of San Pablo Avenue's older businesses had closed and storefronts stood vacant. Emeryville's government moved from Park Avenue's old city hall to a new office building on the peninsula, and the corridor of abandoned factories created a ghostly scene. Renewal efforts have transformed Emeryville's stagnant main strips over the past decade by reintroducing commercial and residential activities. But for those who look closely, history lives.

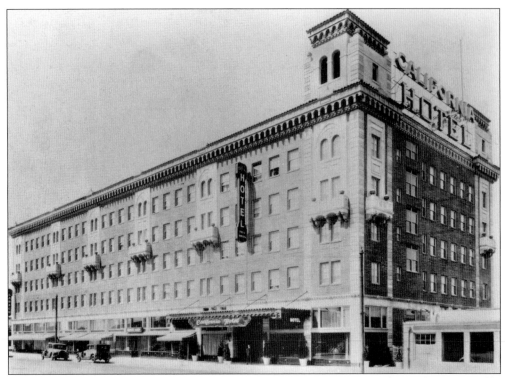

Built in 1929, the five-story California Hotel, pictured here *c.* 1935, was located on San Pablo Avenue next to the Emeryville line. Originally a whites-only establishment, the hotel integrated in 1953 and became an important venue for black celebrities, musicians, and entertainers. The hotel boasted a cocktail lounge, a ballroom, and a 24-hour restaurant. The Oakland Oaks' opposing teams stayed at the hotel when they played in Emeryville. (Courtesy Oakland History Room.)

The subject of this rare 1935 photograph is the construction of the MacArthur Boulevard underpass that went under San Pablo Avenue and served as an approach to the San Francisco-Oakland Bay Bridge. Note the streetcar rolling down San Pablo Avenue and the old two-story, wood-frame building located on the west side of the street. (Courtesy John Harder.)

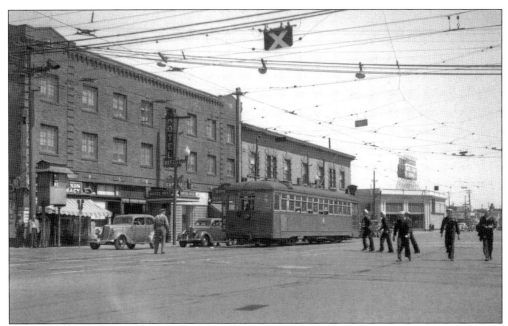

This 1946 photograph looks southeast down San Pablo Avenue at the Yerba Buena Avenue intersection. The Hotel Ritz is on the left, American Trust Company Bank is in the center, and Learner's Garage appears on the right. A flagman is standing center left and sailors are walking on the right. The Key System operated streetcars on San Pablo Avenue until 1948. (Courtesy John Harder.)

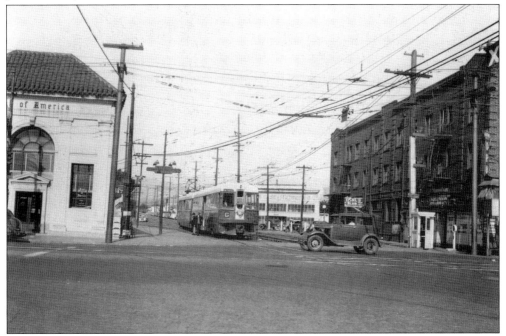

This c. 1946 view looks east at the San Pablo Avenue and Yerba Buena intersection. The Bank of America is on the left, and the Ritz Hotel is on the right. A Key System bridge unit is ready to cross San Pablo Avenue on its way to San Francisco. (Courtesy John Harder.)

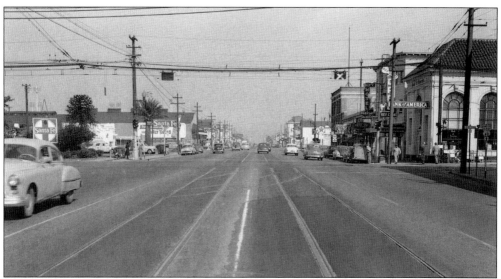

This 1952 view looks north on San Pablo Avenue near the Yerba Buena Avenue intersection. The Bank of America and Key Hotel stand on the right. The Santa Fe sign marks the location of the Santa Fe Depot on the left (not in the photograph). Key System streetcar tracks remain on the street, but service has terminated. (Courtesy John Harder.)

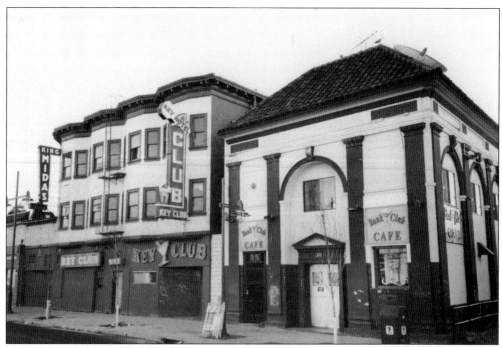

Looking northeast at San Pablo and Yerba Buena Avenues in 1990, the King Midas Club (far left), Key Club and Key Hotel (center left), and Bank Club (center) appear in this view. The building on the right opened as the Bank of America and in 1955 became the Bank Club, a bar, card room, and restaurant. The Key Hotel opened in 1906 and closed in 1989. (Courtesy Emeryville Historical Society.)

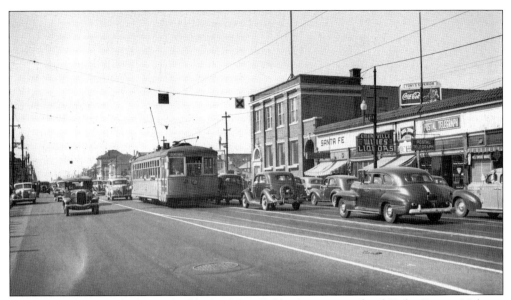

This 1940 photograph shows the block of San Pablo Avenue north of Yerba Buena. Nabisco Company (the two-story brick building), the Santa Fe (a bar and restaurant), Emeryville Wines and Liquors store, and the Postal Telegraph are on the right. All of these buildings have been razed. (Courtesy Emeryville Historical Society.)

A Key System streetcar rumbles across Fortieth Street on its way north to Berkeley in 1940. Ernie's Cafe is on the left. The Santa Fe tracks in the foreground cross San Pablo Avenue and turn north on Adeline Street one block away. (Courtesy California Photo Views.)

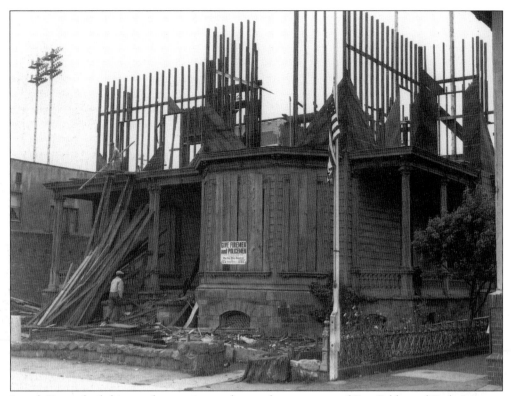

Joseph Emery built his stately mansion at the northwest corner of San Pablo and Park Avenues in 1868. He died in 1909 at the age of 88, and in 1912, the old house was moved one block north to Forty-third Street to make room for the Oaks Ball Park. When the home was razed in 1946, one old-timer sagely remarked, "We shall not see its like again." (Courtesy *Oakland Tribune*.)

A *c.* 1958 nighttime photograph of San Pablo Avenue, looking south on San Pablo Avenue near Forty-fifth Street, provides a view of Berkeley Farms Fountain and E. J. Carey Insurance on the left. Hoky's Restaurant appears on the right. (Courtesy *Oakland Tribune*.)

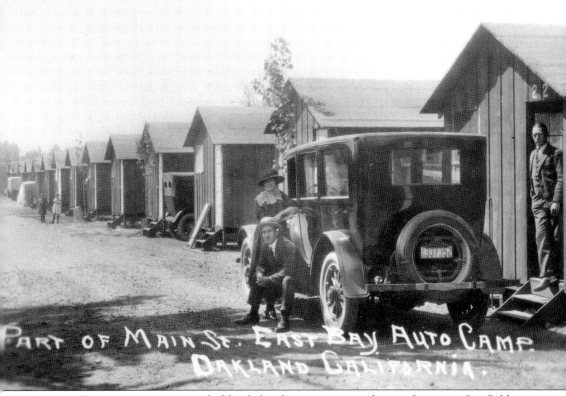

PART OF MAIN St. EAST BAY AUTO CAMP OAKLAND CALIFORNIA.

In Emeryville, a miniature city was hidden behind a gas station and general store on San Pablo Avenue. In this *c.* 1925 picture, three adults pose for the camera and children wander in the background among cars and cabins on Main Street, one of seven dirt roads that comprised the East Bay Auto Camp. Over 250 tiny cabins provided lodging. The camp's public showers that drained into Temescal Creek were an attractive feature for guests that got gritty and grimy while driving on dusty, unpaved roads. Although promotional materials cited Oakland as the camp's location, most of the camp was situated within Emeryville, at 4811 San Pablo Avenue, between Forty-seventh Street and Santa Fe Avenue (now Fifty-third Street). Opening in the early 1920s, the East Bay Auto Camp was an example of a nationwide phenomenon. Referred to as tourists' cottages, cabin camps, or auto camps, these antecedents of the modern motel proliferated by the late 1920s. But Emeryville's auto camp was not a purely recreational amenity. "Permanent" residents paid weekly rates and the camp likely housed seasonal and itinerant laborers. The camp closed by 1929, possibly because of sanitation issues, and the adjacent Emery High School campus absorbed the property to use as an athletic field. (Courtesy Oakland History Room.)

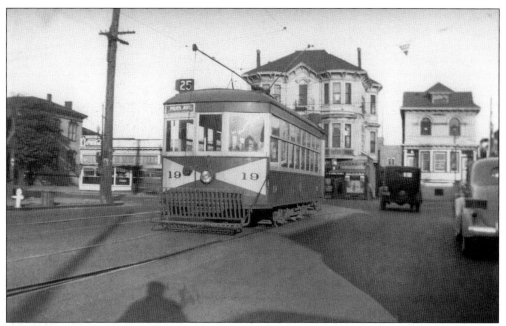

Key System Car No. 19 heads west down Park Avenue from San Pablo Avenue in this 1923 photograph. The line ran along Park Avenue from San Pablo Avenue to the end of the line at the Southern Pacific railroad tracks, a distance of one kilometer. Service on the line ceased in 1937. (Courtesy California Photo Views.)

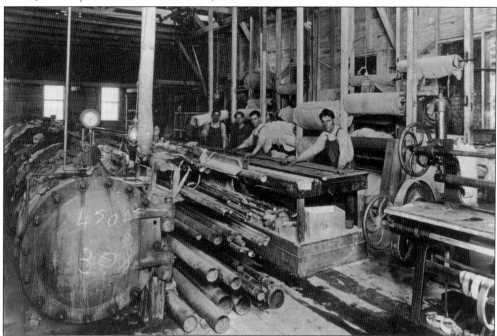

Pictured here in 1910, the American Rubber Company factory opened in 1907 at the corner of Watts Street and Park Avenue. With a workforce of 150 men, the company manufactured rubber conveyor belts, fire hoses, and rubber goods. The two-story brick building was converted into condominiums in 1989. (Courtesy Oakland Museum of California.)

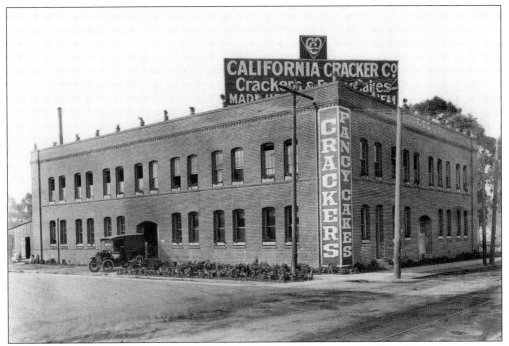

California Cracker opened in 1913 at the east end of Park Avenue at the Watts Street intersection. The company manufactured crackers and fancy cakes. The two-story brick building still exists and now provides office space. (Courtesy California Photo Views.)

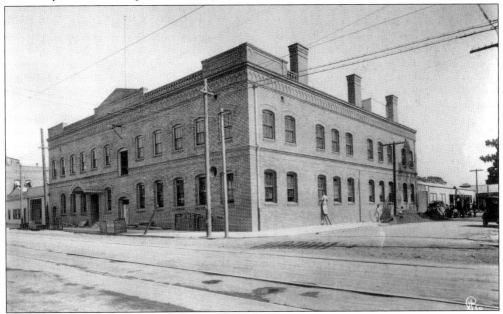

Peoples Baking Company, located at Park Avenue and Harlan Street, opened around 1917 and is pictured here c. 1920. Peoples produced a complete line of baked goods which it delivered to homes and stores in a fleet of trucks painted to match its bread wrappers—red and white gingham checks. The building now houses Folkmanis Puppets. (Courtesy California Photo Views.)

This 1927 photograph of female cannery workers in uniform was taken in front of the employee entrance to the California Packing Company, also known as Plant No. 35, on Park Avenue. The name of the company was changed to Del Monte Corporation in 1967. Plant No. 35 closed in 1989. (Courtesy Jim Layton.)

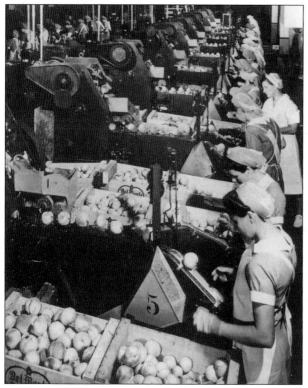

The women on this c. 1940 Del Monte production line are feeding peach pitting machines. The routine involved positioning peaches on a mandrel that carried them into the machine to be halved and pitted. A pair of women fed each machine. (Courtesy Oakland Museum of California.)

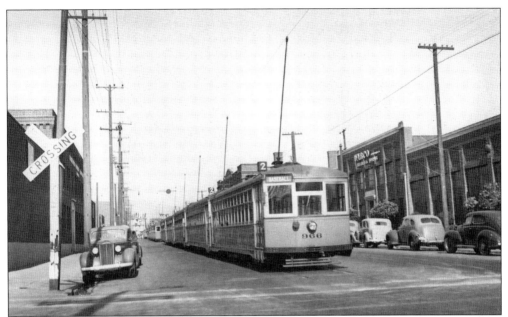

The Key System's "baseball special" streetcars are waiting on Park Avenue for crowds at an Oakland Oaks' baseball game in this 1940 photograph. Previously, this trolley line had primarily served workers at the Virden Cannery (later Del Monte's Plant No. 35, which is pictured on the left), Judson Steel, and other factories located along and adjacent to Park Avenue. In the early 1930s, the Key System eliminated midday service on the Park Avenue line to mitigate declining revenues. Service was limited to morning and evening rush hours. By the 1940s, the Park Avenue line had stopped regular service altogether. Only a short stretch of track was retained to accommodate the baseball special streetcars on game days. In 1949, the last remnant of the Park Avenue track was finally torn up. When this picture was taken, UARCO, a business forms factory, occupied the brick building on the right. Today the building is retrofitted, restored, and adapted for office space. (Courtesy California Photo Views).

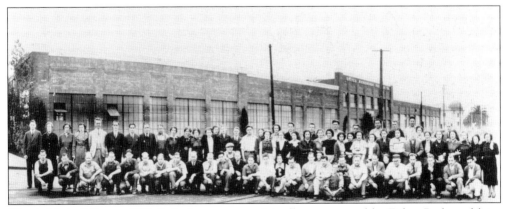

This brick building at 1255 Park Avenue was originally constructed by Fisher Body and later occupied by Walk-A-Thon, Frigidaire, and UARCO. The assembled workers at the United Autographic Register Company (UARCO), a manufacturer of multiform books, lined up for this photograph in 1939. (Courtesy Harry Jensen.)

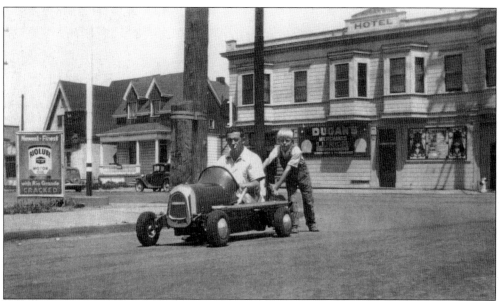

An unusual *c.* 1937 photograph of a miniature car at the corner of Park Avenue and Hollis Street reflects the 1930s interest in midget-car racing. Dugan's Hotel and Restaurant looms in the background. Dugan's burned down in 1949. The house on the left still stands. (Courtesy Ben Yee.)

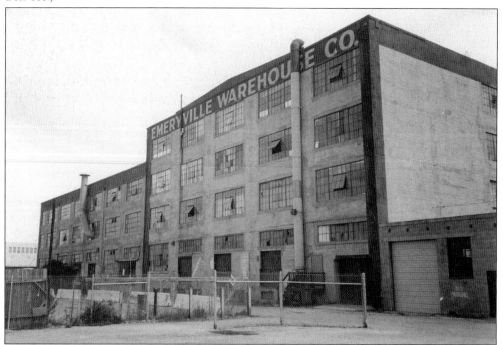

The Emeryville Warehouse Company, a 150,000-square-foot building, is located at the corner of Park Avenue and Hubbard Street. Peck and Hills Furniture Company originally occupied this concrete structure, built in the 1920s. It became the Emeryville Warehouse Company in the 1950s and was converted to live-work lofts in the late 1990s. (Courtesy Emeryville Historical Society.)

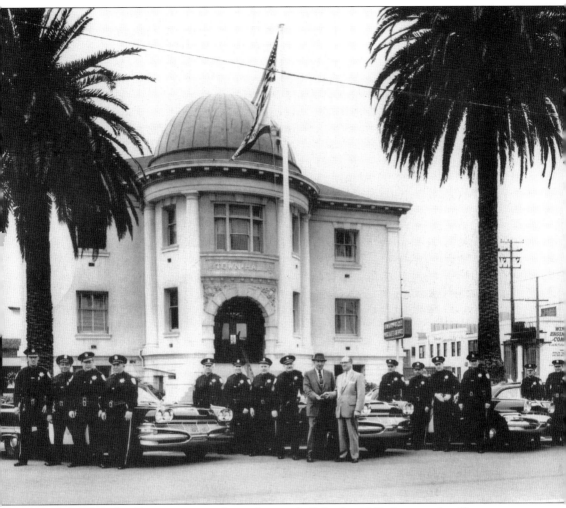

The Emeryville Police Department was located in city hall. In this 1960 photograph, officers pose with a new fleet of Doge Polara patrol cars on Park Avenue. Chief of Police, John Doyle (wearing a suit and hat) is receiving the keys for the vehicles. The sign to the right reads "Emeryville Police Dept.," and the jail is located in the bowels of city hall. After serving Emeryville for nearly 70 years, city hall closed in December 1971. The seat of government and the police department moved to new offices located in a high-rise on Emeryville's peninsula. In 1997, Emeryville's government made plans to move its administrative offices back to the historic core of the city. The old city hall was retrofitted and refurbished, and a 17,500 square-foot glass-walled wing, designed by Fisher-Friedman Architects, was completed in 2001. The city staff moved back into the old city hall (now called the Emeryville Civic Center), but the police department remains in the Powell Street office tower. (Courtesy Larry J. Doyle.)

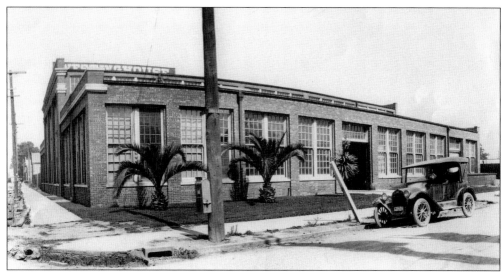

The Westinghouse-Pacific Coast Brake Company, located at 155 Park Avenue, was established in 1912, and this photograph was taken soon after it opened. The factory manufactured air brakes, but is now occupied by Trader Vic's food warehouse. (Courtesy California Photo Views.)

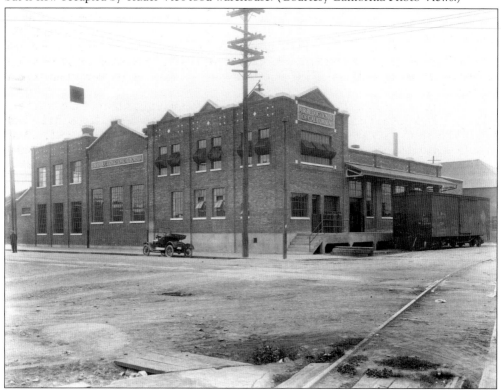

A company that manufactured oxygen tanks for welding, Air Reduction Incorporated was built in 1917 at the foot of Park Avenue next to the railroad tracks. The elaborate brickwork features a stepped parapet and panels of herringbone brick. The two-story building survives nearly unchanged and is now occupied by Pelco-Pellegrini Company. (Courtesy California Photo Views.)

Nine

EMERYVILLE IN THE SECOND GOLD RUSH
WORLD WAR II

The December 7, 1941, Japanese attack on Pearl Harbor stunned Emeryville's residents; then the realities of war hit home. On December 14, newspapers reported that Ensign Jack Emery, grandson of Joseph Emery, had been killed during the bombings, and Governor Culbert Olson declared a "state of emergency" in California. As the United States entered World War II, federal money poured into the Bay Area's shipbuilding and defense industries, and new economic opportunities triggered a second gold rush. In Emeryville, old-timers mobilized for the possibilities of attack, while newcomers joined the workforce in order to construct an "arsenal for democracy."

Due to its concentration of industries and transportation infrastructure, the California State War Council identified Emeryville as a "Number One Priority Community." Mayor Al LaCoste helped implement a comprehensive Civilian Defense Plan, and Emery High School students joined the effort by peddling war stamps and war bonds, planting victory gardens, and collecting scrap metal. More significantly, 111 graduates of Emery High had enlisted in the military by April 1943. All the while, Emeryville's Veterans of Foreign Wars Post 1010 grew.

As Emeryville's residents were mobilized, the city's factories, foundries, and fabricators retooled their shops and fined-tuned their assembly lines for the defense buildup. Operating three shifts on a 24-hours-a-day schedule, Emeryville's 185 industrial firms required a workforce of close to 30,000 to fulfill government contracts. With the draft and demands of around-the-clock production, Emeryville, like other industrial areas in California, faced an acute labor shortage.

Although figuratively lumped together as "Okies," the Bay Area's migrant laborers came from all 48 states and included families and single women. While "Rosie the Riveter" worked at Kaiser's Richmond shipyards, Emeryville's production plants employed women machinists and assembly-line workers. Jim Crow pushed, and economic opportunity pulled thousands of southern African Americans toward the industrial boom. Discriminatory hiring practices and mistreatment aside, African Americans and other minorities found an entry into the unionized workforce in Emeryville.

Wartime paranoia peaked in February 1942, when President Roosevelt ordered the mass expulsion of all Japanese Americans from the West Coast. Raylso Sekguchi, a Japanese American senior at Emery High, was forcibly relocated along with her family to Topaz Internment Camp in Utah. Long after the factories closed, Emery High School remembered Raylso. In 2004, Principal Mark Miller invited her to the graduation ceremony. At the age of 79, she finally received her diploma.

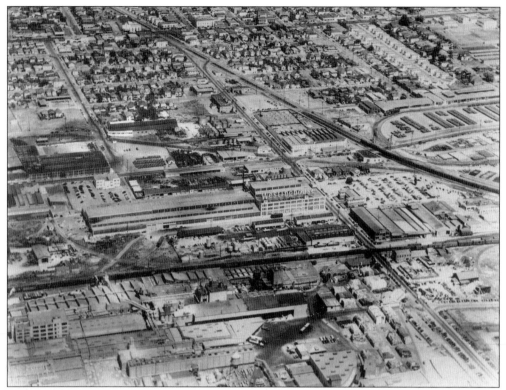

This *c.* 1945 aerial photograph shows Emeryville at the time of World War II. Westinghouse Electric is in the center, and the Paraffine Companies plant appears in the foreground. San Pablo Avenue runs from left to right near the top, and the Southern Pacific tracks cross near the bottom. Military vehicles are lined up in the center right of the photograph. (Courtesy *Oakland Tribune.*)

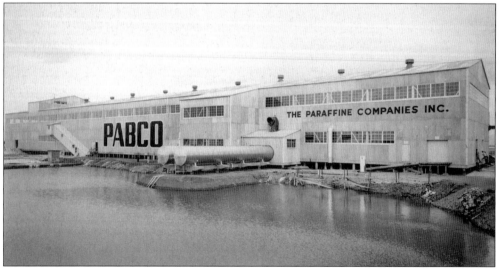

Located at the foot of Powell Street, the Paraffine Companies, later known as Pabco, employed 3,000 workers during the war years. The plant manufactured a long list of materials vital to the war effort and maintained production 24 hours a day. (Courtesy California Photo Views.)

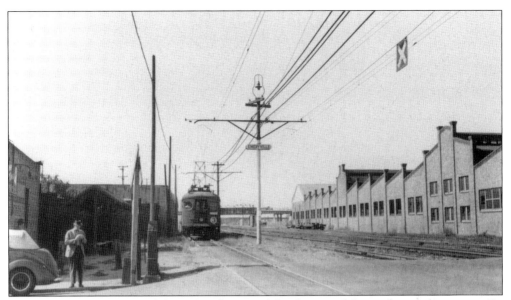

The Judson Steel plant (right) produced material for the armed forces during the war era. In this c. 1941 photograph, a Southern Pacific Red Train (center) is passing through Emeryville on its way to San Francisco. Park Avenue is on the left. (Photograph by J. T. Graham; courtesy Oakland History Room.)

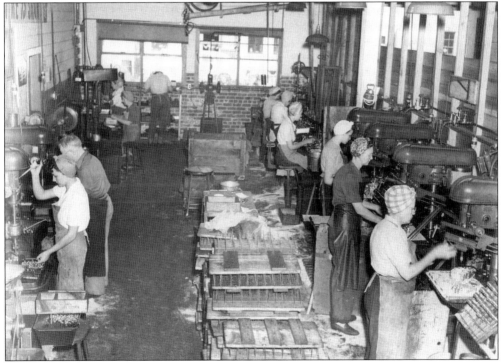

Female machinists operate drill presses on an assembly line at the Albert Wright Screw Machine Products Manufacturing Company in 1944. The sign on the left wall reads "Time is Short." Overhead flat belts in back of the room powered the machinery. (Courtesy Emeryville Historical Society.)

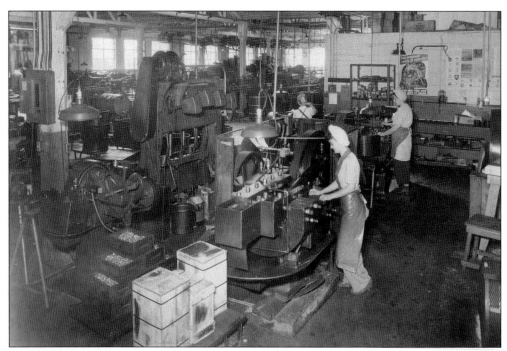

The woman in the foreground is operating a thread roller and trimmer machine at the Albert Wright Company on Hollis Street in 1944. The one-story brick building still stands. (Courtesy Emeryville Historical Society.)

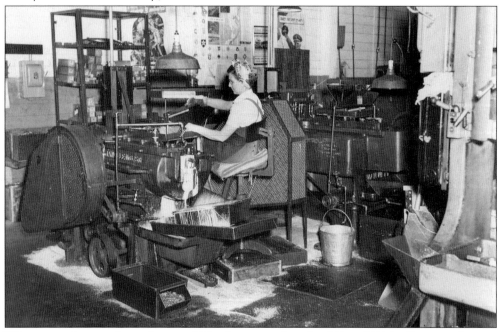

This woman is operating a shaper, which planes metal, at the Albert Wright Company factory, around 1944. World War II posters can be seen on the wall. The factory manufactured screw machine products and was awarded the U.S. Army and Navy "E" Award for excellence in production during World War II. (Courtesy Emeryville Historical Society.)

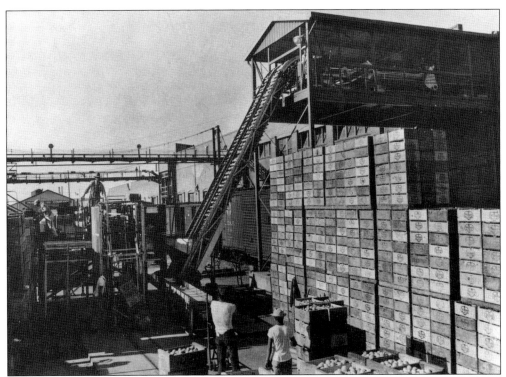

The canning industry provided a vital product for the home front and the armed forces. California Packing Corporation (Del Monte) on Park Avenue operated 24 hours a day at the peak of the harvesting season. This *c.* 1942 photograph features the south side of Plant No. 35. (Courtesy Oakland Museum of California.)

The Grove Regulator Plant, pictured here in 1947, was located at Sixty-fifth and Hollis Streets. Marvin Grove built it in 1943 at the request of the U.S. Navy. The company, which had a workforce of 350, produced valves for ships during World War II. (Courtesy Emeryville Historical Society.)

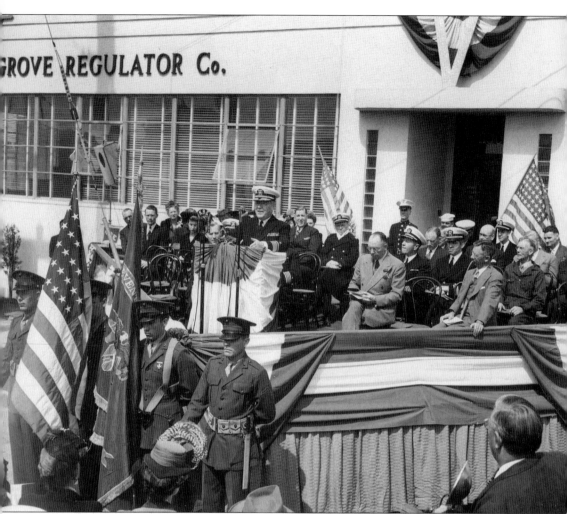

Grove Regulator Company supplied the U.S. Navy with products that were vital to the war effort. Because of the company's record of productive achievement, Rear Adm. John W. Greenslade presented the Navy "E" Award (the letter "e" stood for excellence) to the management and employees of the plant on March 27, 1942. (Courtesy Emeryville Historical Society.)

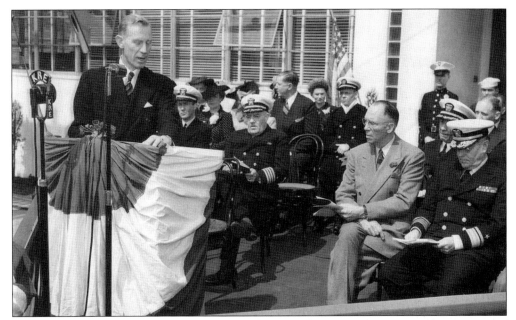

After the presentation of the Navy "E" Award for excellence, Marvin Grove, the manager of Grove Regulator Company, addressed the audience with the navy brass in the background. On this occasion he made the following remarks: "In receiving the Navy "E" Award, we have today enlisted to serve wholeheartedly in the front line of production. Our production line is our battle line." (Courtesy Emeryville Historical Society.)

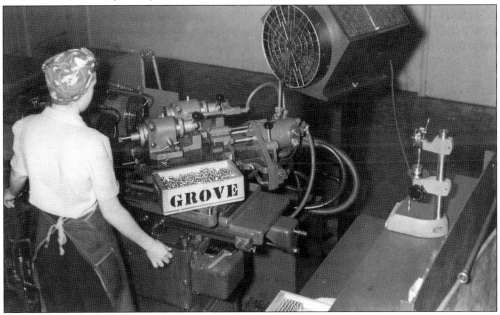

A "tiny army of women" in bandannas and denim aprons operated lathes and other power tools at the Grove Regulator Company during the war years. Female employees received extensive training in the use of equipment, and many were required to complete first-aid courses and safety-engineering courses because of the hazardous nature of the work. (Courtesy Emeryville Historical Society.)

The Veterans Memorial Building on Salem Street served as the headquarters of Emeryville Industrial Post No. 1010. This veterans' organization sponsored social and athletic events for members, including dances, bowling, rifle team, baseball, and band. The art deco building was equipped with a pool room, kitchen, and auditorium on the first floor and a lodge room on the second floor. (Courtesy Emeryville Historical Society.)

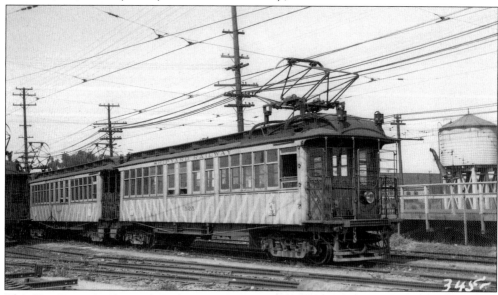

The Key System's Shipyard Railway cars 527 and 525 repose at the Hollis Street Yards. The Shipyard Railway carried shipyard workers from Emeryville to Richmond. The line started at Yerba Buena Avenue and Hollis Street, turned north on San Pablo Avenue, turned west at Grayson Street in Berkeley, and then connected with the old Ninth Street Southern Pacific line. Service began on January 18, 1943, and terminated September 30, 1945. (Courtesy Vernon Sappers.)

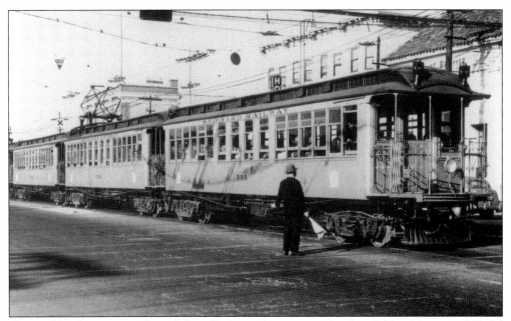

Shipyard Railway cars, inbound from Richmond, arrive at the San Pablo Avenue and Yerba Buena intersection in Emeryville in 1944. The Bank of America (right), the Key Hotel (center), and Nabisco building (left) are in the background. Note the flagman standing in the street, warning approaching traffic of the train's arrival. Shipyard Railway units were originally New York City subway cars. (Photograph by J. G. Graham; courtesy Oakland History Room.)

General Cable Corporation at 6201 Green Street (later Hollis) manufactured insulated electric wires and cables during World War II. The company received the meritorious "M" pennant in July 1943 from the U.S. Maritime Commission for outstanding achievement in war production. The guard tower, photographed in 1990, protected valuable copper wire and cable stored in the yard. (Courtesy Emeryville Historical Society.)

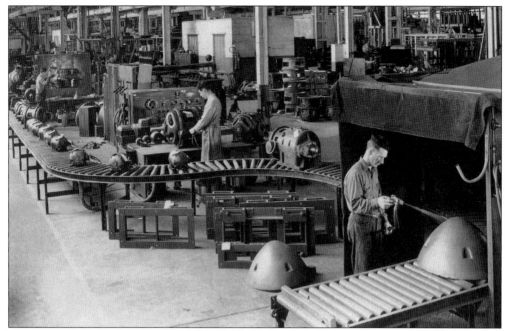

Two men work on a generator in the north wing of the Westinghouse plant in this 1943 photograph. Overhead cranes moved heavy machinery. During World War II, Westinghouse Electric manufactured and assembled electrical apparatus. In September 1945, the company won the Navy "E" Award for outstanding work. (Courtesy *Oakland Tribune*.)

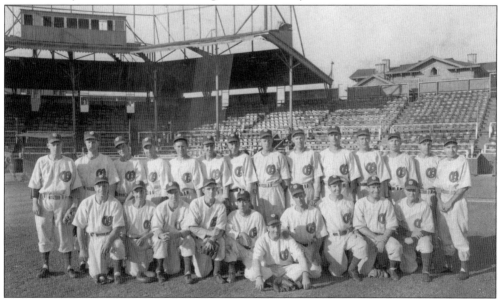

President Roosevelt was an ardent baseball fan who advocated the continuation of organized baseball during wartime for the morale of factory workers. The Pacific Coast League teams, including the Oakland Oaks, played during the war years. In this 1944 photograph, Dolph Camilli, team manager, is kneeling in the first row on the far left. In the second row, standing second from right, is Les Scarsella, team batting leader with a .329 average. (Courtesy Ray Raineri.)

Ten

REBIRTH

THE CONTEMPORARY CITY

Imaginations ran wild on Emeryville's shoreline. Kangaroos romped in the shadow of a giant peace sign, Don Quixote challenged a windmill, and Snoopy, seated in his Sopwith Camel biplane, kept a lookout for the Red Baron. Beginning in the late 1960s, playful artists and political activists transformed Emeryville's mudflats into a driftwood sculpture gallery. Looking west against a backdrop of the bay, the scene entertained thousands of commuters. When commuters cast their gaze east toward the interior of the city, however, the outlook was grim.

In the late 1960s, heavy industries began fleeing Emeryville in search of suburban locations. Yet, during the protracted decline of heavy industry, Emeryville subtly evolved. The city's ingratiating government, central location, and cheap, adaptable buildings attracted small high-tech industries and niche manufacturers, as well as artists that colonized former warehouses. It was not gentrification, but gradual and piecemeal adaptation as the seeds of the contemporary redevelopment boom were planted.

While the interior of the city struggled with its industrial past, Emeryville's future spilled into the bay. In the early 1970s, a hook-shaped peninsula was constructed with bay fill. Thousands of new residents filled luxury apartments and swanky restaurants as new office towers ascended above the old smokestacks. The newcomers' private swimming pools and marina drew the problems of east Emeryville's neighborhoods into sharp relief. Hemmed in by factories and a tattered stretch of San Pablo Avenue, old Emeryville was branded by local media as the "least desirable place to live in the Bay Area."

Protests surrounding the monolithic Pacific Park Plaza condominiums helped precipitate Emeryville's transformation. An alliance of old and new residents and East Bay environmentalists ousted a city council that they blamed for selling out the city. In 1987, Emeryville's voters elected a new slate promulgating environmentally appropriate growth and "good government." Since then, Emeryville has experienced a redevelopment boom unmatched in the East Bay.

The hollowed-out places and contaminated spaces abandoned by industry now contain a densely packed montage of over 30 redevelopment projects. Emeryville's four malls and IKEA store have collectively created a retail mecca. Chiron and Pixar have developed high-profile research and design campuses. Housing units in converted lofts and high-density apartments have doubled the population, while three new high-rise hotels exploit Emeryville's central location. Emeryville's transmutation from an industrial wasteland to the East Bay's downtown is nearly complete.

The city is not without its problems. Like other cities in the Bay Area, rising housing costs have displaced low-income residents. Although redevelopment projects have created thousands of new jobs, many service-sector workers cannot afford to live in Emeryville. The city is plagued with traffic congestion previously unknown north of Los Angeles. Nevertheless, there is great reason for optimism, as Emeryville's ever-increasing revenues are funding expanded public services, and its affordable housing program makes immense strides. As always, Emeryville is in flux.

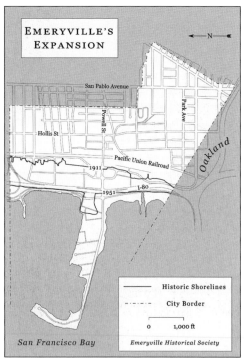

EMERYVILLE'S EXPANSION

San Pablo Avenue

Park Ave

Powell St.

Hollis St

Pacific Union Railroad

Oakland

1911

1951 I-80

Historic Shorelines
City Border

0 1,000 ft

San Francisco Bay Emeryville Historical Society

Enveloped by Oakland and Berkeley, tiny Emeryville had only one way to expand—into the bay. In the 1930s, the East Shore Highway bored through Emeryville's mudflats, creating an unpleasant lagoon between Butchertown's waterfront piers and the new highway. Emeryville's landowners seized the opportunity for expansion, eventually filling 250 acres. In the late 1960s, the city continued to spread westward on filled tidelands with the development of the Emeryville peninsula, which transformed both the physical and socio-economic landscapes.

During the 1960s and 1970s, local artists and sculptors fashioned strange objects from driftwood and junk at the Emeryville mudflats. D. A. Puccio and R. D. Kirkpatrick are credited with building this train engine photographed in 1980. All of the original sculptures have been removed and the shoreline has returned to "nature" as Eastshore State Park. (Courtesy George Post.)

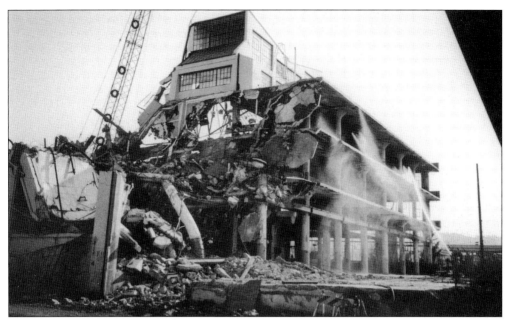

Built in 1924, Westinghouse Electric Corporation's regional warehouse stood for decades on Peladeau Street. In 1989, the ornate concrete building was severely damaged by the Loma Prieta earthquake. In 1993, the plant succumbed to the wrecker's ball, and a new brick mixed-use building, Emery Station North, arose on the site. (Courtesy Emeryville Historical Society.)

Barbary Coast Steel operated the venerable Judson Steel plant at the foot of Park Avenue for a brief period in the late 1980s. After a century of operation, the firm closed in 1991. The plant was disassembled in 1992 and shipped to Seattle. (Courtesy Emeryville Historical Society.)

In 1972, a new Holiday Inn opened on the Watergate Peninsula next to the Eastshore Freeway. The 14-story high-rise included 300 rooms and banquet facilities for 400. The Emeryville Municipal Heliport briefly provided helicopter shuttle service between Emeryville and the San Francisco Airport. SFO Helicopter Airlines ceased operation in 1976 due to bankruptcy. (Courtesy Emeryville Chamber of Commerce.)

The 80-acre, mile-long Watergate Peninsula bay-fill project, built during the 1970s, consists of office buildings, apartments, a hotel, restaurants, and a park. The 600-berth Emeryville Marina, pictured here in 1976, features a launch ramp, bait and tackle shop, a fuel facility, showers and laundry, and a fleet of sport fishing boats. (Courtesy *Oakland Tribune*.)

The Pacific Park Plaza, completed in 1984 next to the Eastshore Freeway and pictured *c*. 1990, proved to be controversial. The sheer mass of the 30-story, 583-condominium high-rise sparked community protests that led to the ouster of city council members who supported the project. Tenants later sued the builder when it was discovered that wind and rain permeated the building's plastic foam exterior. (Courtesy Yalda Modabber.)

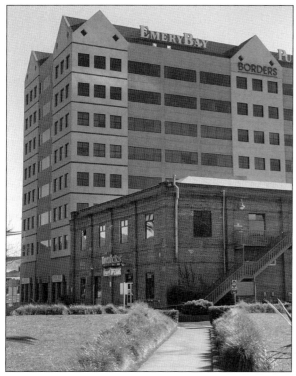

The Martin Group built a 544-unit apartment complex (Emerybay Apartments), glass-walled office buildings for Cybase, (Bay Center Offices), and Emerybay Marketplace, pictured above, on the former Pabco site and adjacent trucking yards. Pabco's old linoleum warehouse was incorporated into the Emerybay Marketplace's design, which includes a 3,600-seat, multiscreen United Artist movie theater, an 11-story office tower, and expansive retail space. (Courtesy Yalda Modabber.)

123

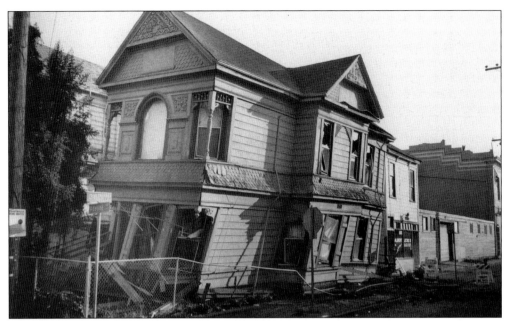

This old two-story house at the corner of Adeline and Thirty-sixth Streets was knocked off its foundation by the Loma Prieta earthquake in 1989. Several major structures in Emeryville suffered extensive damage, including the old Westinghouse Electric plant on Peladeau Street. (Courtesy Emeryville Historical Society.)

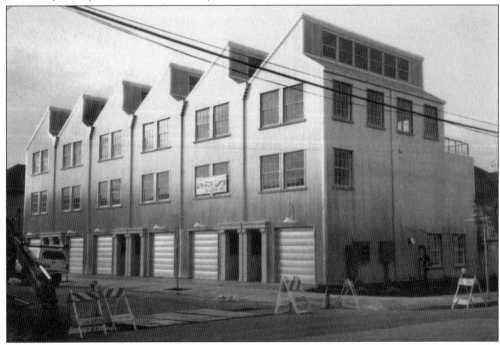

Many fine specimens of innovative housing have been built in Emeryville over the past 20 years. Designed by Joseph Costarella, this live-work loft's jagged roofline and shiny metal exterior references Emeryville's industrial past. Originally built on Emery Street in the early 1990s, it was later moved to Park Avenue. (Courtesy Emeryville Historical Society.)

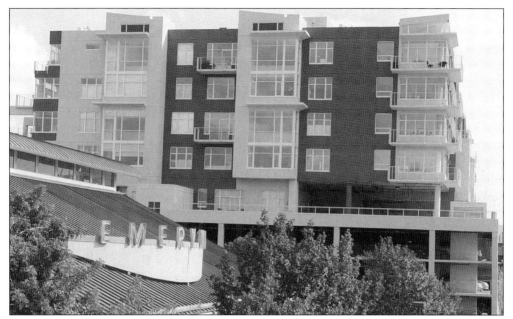

EmeryStation Plaza consists of a three-building complex on a 10-acre site formerly occupied by a Standard Oil Company distribution center and a Westinghouse transformer factory. Surrounding the Amtrak station, this redevelopment project combines densely packed office and retail space with housing. The Terraces, pictured above, includes 101 "lofts" and "flats" over a four-story, 732-space parking structure. (Courtesy Yalda Modabber.)

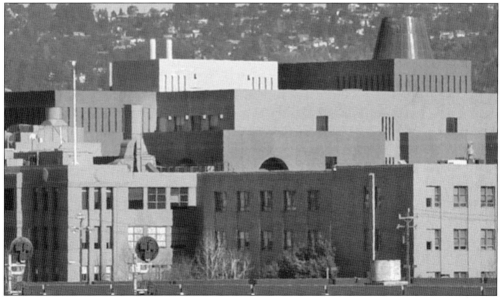

Emeryville's Cetus Corporation emerged as one of the world's largest biotechnology firms during the early 1980s "biotech boom." A second biotech firm, Chiron Corporation, soon followed and eventually acquired Cetus. In 1998, Ricardo Legorreta designed Chiron's Life Science Center (above). Remediation of the site required the removal of 60,000 cubic yards of contaminated materials. It is the largest facility of its kind in the region, and Emeryville's biggest employer. (Courtesy Yalda Modabber.)

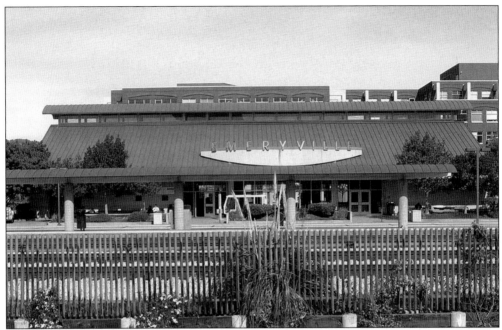

Completed in 1993, the Amtrak station at 5885 Landregan Street is across the tracks from the Emerybay Public Market. An overpass with elevators allows pedestrians to cross the tracks. (Courtesy Yalda Modabber.)

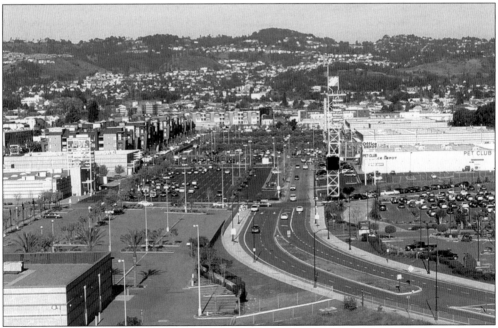

East Baybridge Mall is one of Emeryville's four regional shopping destinations. Built on the site of the old Santa Fe railroad yard and Yerba Buena corridor, the mall straddles the border with Oakland. Here "big box" retailers such as Home Depot got a foothold in the East Bay in the early 1990s. The Baybridge Apartments (upper left) includes 100 units of affordable housing. (Courtesy Yalda Modabber.)

Completed in 2002, EmeryStation North provides 200,000 square feet of office space, ground-floor retail and parking. From 1990 to 2002, redevelopment projects produced over three million square feet of office space, ranking Emeryville second behind Oakland in the amount of leasable office space per city among all East Bay cities on the Interstate 880 corridor. (Courtesy Yalda Modabber.)

In the early 1990s, reactions to Emeryville's redevelopment took many forms. This mural referenced the public health risks caused by a century's worth of industrial pollution. In 1996, a grant from the Environmental Protection Agency funded Emeryville's Brownfields Redevelopment Pilot Project. The project facilitated comprehensive environmental clean-up and 22 redevelopment projects between 1996 and 2001. (Courtesy Emeryville Historical Society.)

Designed by Soderberg and built in 1903, the neoclassical town hall (far right) at the southeast corner of Park Avenue and Hollis Street served as the seat of Emeryville government until 1971. Following a retrofit project, it reopened for city business. A new civic center, a futuristic glass-and-steel structure, opened in 2000 as an annex to the old town hall. (Courtesy Yalda Modabber.)

This monument to Ohlone culture was part of the redevelopment deal for Emeryville's ersatz "Main Street," Bay Street Mall. For some, the monument, which sits on tops of Ohlone remains, symbolizes the defilement of a sacred site. For others, it represents the crowning element on a model of urban renewal. Either way, people flock to Emeryville, the restless city with an unknown destiny. (Courtesy Yalda Modabber.)